BRUEGEL

BRUEGEL

Robert L. Delevoy

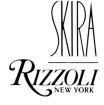

SKIRA

RIZZOLI
NEW YORK

Cover Illustration:
The Fight Between Carnival and Lent, 1559, detail

First published 1959
First paperback edition 1990

Translated from the French by Stuart Gilbert

Published in the United States of America in 1990 by

*R*IZZOLI *INTERNATIONAL PUBLICATIONS, INC.*
300 Park Avenue South/New York 10010

© 1990 by Editions d'Art Albert Skira S.A., Geneva

ISBN 0-8478-1349-5
LC 90-50884

Printed in Switzerland

CONTENTS

The Painter and the Connoisseur, about 1565. Drawing.

THE LIFE OF BRUEGEL

AN UNCLEAR PROFILE

> What does he mean to me, this man who
> steps in between humanity and myself?. . .
> It is not he, it is nature, it is humanity
> working at a given point in time and space
> that is the true author.
>
> ERNEST RENAN

THE scenes and incidents that Bruegel has recorded in his draw-
ings, prints and pictures still supply us with the best means to
an understanding of the successive phases of his life. For despite
the unflagging efforts of an impressive number of art historians since
the beginning of this century, little or no progress has been made
towards defining the somewhat unclear profile of the artist given by
Carel van Mander, in 1604, in his famous *Schilderboek*. The skeleton
biography compiled by that eminent chronicler of early Netherlandish
painting lacks some key pieces of information which all the industry
of erudite researchers has so far failed to uncover or reconstitute. We
have only conjectures to go on as to the master's birthplace and the date
of his birth, the social background of his early years, how and when
he took to painting, the time he came to Antwerp, the exact itineraries
of his travels, the real reasons for his move to Brussels and the circum-
stances of his early death.

True, a precise knowledge of the facts might (as so often happens
in such cases) tend to give undue prominence to anecdotal elements

and submerge essentials in a mass of that "factual" apparatus whose limitations—narrowness of outlook, tameness and triviality—are only too familiar to us. Since, however, individual experience is always bound up with collective experience, we shall find in the latter a compensation for the lacunae of the former. Those very lacunae, in any case, have stimulated research work and critical scrutiny of the œuvre itself to such effect as to lend color to the view expressed by the Indian poet Rabindranath Tagore: that in such cases all that is most important lies outside the artist's personal vicissitudes, his manner of living and day-to-day events—all, in short, that would normally figure in a full-length biography.

Broadly speaking, then, Bruegel's life story is largely a matter of guesswork, and approximative at best. This did not, however, cramp the prolific imagination of a Flemish writer, Felix Timmermans, author of a *vie romancée* of the artist which has been translated into several languages and of which the least that can be said is that it displays a singular disregard for truth. All the fully authenticated evidence available, so far anyhow, consists of five documents dating to the master's lifetime: an entry in the lists of a painters' guild; two letters written by the Bolognese geographer Scipio Fabius, dated June 16, 1561, and April 14, 1565; a record of Bruegel's marriage in the register of Notre-Dame-de-la-Chapelle at Brussels; a brief mention of him by Guicciardini in 1567. If it could be proved that the name "Meesteren van Pieter Bruegel" which figures in the minutes of a meeting of the Brussels City Council that took place on January 18, 1569, refers to him, we should have a sixth piece of documentary evidence, informing us that at this time Bruegel was exempted from having to quarter Spanish soldiers and was given a sum of money.

The first of these documents is a sadly laconic but invaluable entry in the registers of the Guild of St. Luke at Antwerp where the name *Peeter Brueghels, schilder* appears along with those of thirty-six painters, engravers and craftsmen admitted to membership in 1551. This is conclusive proof that a certain "Peeter Brueghels, painter" existed and

was at Antwerp during the reign of the Emperor Charles V. Though this official, colorless, objective entry, figuring as it does between the names of an engraver, Ghisi, and a painter, Martin van Cleve, may seem at first sight as unrevealing as a regimental number, something may be gleaned from it. For it contains what is generally accepted as a clue to the painter's place of origin, since the "s" at the end of the name can be taken as an adjectival termination, meaning that the "Peeter" in question hailed from a place named Brueghel.

On this view, our "Peeter," lacking a family name—as was common at the time, especially among the peasantry—decided to adopt as his surname the name of his birthplace. But exactly where this was is still a moot point. For there are no less than three ancient villages with the name Brueghel (or Brögel). One is in the former Duchy of Brabant some sixty miles from Antwerp and a little over five miles north of Eindhoven; it now belongs to the parish of Son (in present-day Holland) and boasts of a modern monument to the memory of the painter. The two other (adjoining) villages, Kleine-Brögel and Groote-Brögel, situated some thirty-six miles south of the Brueghel in Holland, are a little over three miles away from the small town of Brée. Formerly they lay within the principality of Liège, but they are now included in the Limburg province of Belgium.

All three are situated in the region, common to Belgium and Holland, known as the Campine. This is a wide expanse of moors and heather, sand and meadows, polled willows and fir plantations, that becomes slightly hilly west of the Dutch village, where there are some small stagnant lakes, dating perhaps to very ancient times. Allowing for the changes this region must have undergone with the passing centuries, I should be inclined to accept the views of Edouard Michel who on the strength of some of Bruegel's landscapes (drawings and paintings) claims to see distinctively "Bruegelian" qualities in the Dutch countryside, were it not that the Brabantine countryside in the neighborhood of Brussels also has, even at the present time, many of the same characteristics. Moreover, there is nothing to justify

us in assuming that after leaving his (presumed) native place in very early youth, Bruegel ever had occasion to return to it.

In this context we do well to bear in mind the positive assertion made by one of his contemporaries. In his celebrated *Descrittione di tutti i Paesi Bassi*, published in 1567, Ludovico Guicciardini definitely states that Pieter Bruegel hailed from Breda. This statement was partially endorsed thirty-seven years later by Van Mander, who tells us that Bruegel "was born not far from Breda in a village named Breughel, a name he took for himself and handed on to his descendants."

Actually there does not exist, and has never existed, a village in the neighborhood of Breda bearing the painter's name; the three villages of that name are some forty-four and thirty miles distant from Breda. This led Van Bastelaer to put forward the theory, which has much to commend it, that the "Breda" to which Guicciardini and Van Mander referred was in reality the small town of Brée, near which are the two villages named Brögel. Brée was, in fact, once called Brede and, in Latin, Brida and Breda (see Van Bastelaer and Hulin de Loo, *Peter Bruegel l'Ancien*, Brussels 1907). As a result of investigations by Charles Bossus, it is now established that the name of this town was spelt Breda in 1078, Brida a year later, Briede in 1335, Brede in the 15th century and, in the 16th and 17th centuries, Bréda; it was not till the next century that the name Brea and its present form, Brée, came into currency. Moreover, in 17th-century documents the name "Groote-Brögel" was written "Breughel."

Finally, due weight should be given to the widely current oral tradition that the painter was born in the large, centuries-old farmhouse at the place named "Ooievaarsnest" (Stork's Nest) in the parish of Groote-Brögel, two or three hundred yards distant from the small road connecting Brée with the market town of Peer. This farmhouse was partially destroyed by fire in 1866, but it has been rebuilt according to the original plan above a masonry substructure that may well go back to the 13th century. It would seem that in the 16th century the farm belonged to the de Hornes family, and Charles Bossus has suggested

that Count Philippe de Hornes, subsequently one of the Duke of Alva's many victims, may very well have noticed the young peasant's talent and supervised his artistic training. Bossus carries his theory, which rests on the slenderest foundations, a stage further and would have us believe that, thirty years later, Bruegel joined with his former patron in the northerners' revolt against their Spanish overlords. He thinks that he has thus "definitively" established the birthplace of Pieter Bruegel the Elder. Unfortunately a local tradition, no less positive and persistent than the Belgian tradition mentioned above, attaches to the Dutch village Brueghel-Son, and according to it the painter was a foundling who was adopted by a family of peasants living on a farm which no longer exists today and which also had the name of "Ooievaarsnest." The parish priest, struck by the boy's talent, arranged for his training at Eindhoven where (again according to the legend) he sold some of his first drawings and made a copy of the *Disciples at Emmaus* for the local church. In short, the early history of this great artist is, as so often happens in such cases, enveloped in a mist of conflicting legends.

For after this recourse to the sources, we can but admit that the central problem remains unsolved, or in any case obfuscated by "a cloud of unknowing." True, the probabilities are strongly in favor of the view that Groote-Brögel in the neighborhood of Brée (also known as Breda) was our painter's birthplace. Yet allowance must be made for the fact that the records of the Guild of St. Luke usually specify the places of origin of artists who have no patronym by adding the word "van" and the name of a locality (e.g. Joos van Cleve, Pieter van Aelst, Jan van Venloo, Jan van Mechelen, *et al.*). And there is nothing to prevent our regarding the vocable "Peeter Brueghels" not as an adjectival form but as a genitive: meaning "Peeter son of Brueghel," not "Peeter hailing from Brueghel." Credence is lent to this conjecture by the fact that several persons of almost the same name are known to have existed in the 16th century; there was a Canon Michael Breughel at Antwerp, a doctor at Brussels styled in a Latin text

"Magister Bruegelius," and a certain "Guillaume van Breughel" was a prominent figure at the Court of Brabant. Also, at Amsterdam, a poet, Gerrit Hendriksz. van Breughel, is recorded as being a member of a Chamber of Rhetoric in the early 17th century. No connection between these persons and the painter's family has so far been traced. Finally—to make confusion worse confounded—we have to bear in mind the fact that persons having a family name sometimes added a topographic surname, such as Bruegel (see Van Bastelaer, *op. cit.*). Thus, all efforts notwithstanding, we are left in the dark as to the geographic and social background of one of the greatest artists of all time. Perhaps indeed there is more wisdom in the skeptical smile with which the Limburg farmer at Ooievaarsnest greets the enthusiastic pilgrim than in the hasty conclusions of some of our art historians.

The lack of documentary evidence makes itself felt no less acutely when attempts are made to ascertain the date of Bruegel's birth. The only reliable clue we have is the entry in the records of the Antwerp painters' guild. It is generally held that an artist had to put in six years' apprenticeship before he qualified as a "free master." Ever since Henri Hymans advanced the theory, in 1890, that this period of training began when the candidate was fifteen to seventeen years old, art historians have assumed that when Bruegel was admitted as a master in 1551 he must have been about twenty-three, i.e. that he was born around 1528. This chronology may, however, be slightly modified.

For there were very few artists who qualified as masters at such an early age. Rubens was an exception, Pieter Coeck and Joachim Beuckelaer were twenty-five, Jan Metsys and Gonzales Coques twenty-six, Pieter Aertsen was twenty-seven and "Velvet" Brueghel twenty-nine. We should be more inclined to assume exceptional precocity in Bruegel's case, were it not that one of his most brilliant contemporaries and a personal friend of his, Abraham Ortelius, tells us that the "most absolute" (i.e. perfect) painter of his century—a fact that could be gainsaid "only by enviers and ignoramuses"—died in 1569 "in the flower of his age" (*medio aetatis flore*), meaning what was then

regarded as the medial point of a man's active life, his forty-fifth year. This would imply that Bruegel was born about the year 1525 and was twenty-six when he obtained his "master's degree"—an estimate supported by the two or three extant portraits showing him at the height of his powers and representing a man seemingly in his early forties. In the present state of our knowledge, any more precise estimate would be imprudent, and there is little hope of clearing up the matter. Thus the assertion made by Charles Bossus in an article in the *Gazette des Beaux-Arts* (February 1953) to the effect that he believes he can fix "with absolute certainty" the year of Bruegel's birth as 1522 seems rash, to say the least.

Any survey of Bruegel's career up to 1551 can be little more than a series of almost unanswerable queries. What were the social and cultural origins of this painter whom we may fancy we know so well —so popular has he become—but who has in fact guarded his secret so intriguingly? Where and how, one wonders, did he acquire the habit of scanning the world with a gaze so eager and so ruthless? What of the early years of this many-sided genius? Did he go directly to Antwerp from his hometown or did he begin by trying his chance elsewhere? True, we know that the answers to these questions could not have any bearing on the essential values of his work. Yet they would be reassuring after a manner, would satisfy legitimate curiosity and—best of all—might put a stop to idle speculations about the man and his message.

It is in that excellent source book, Van Mander's *Schilderboek* (published in 1604), that we have the first piece of information (somewhat late in date, however) about Bruegel's activities in the years before he qualified as a free master. Van Mander tells us that "he learnt his craft from Pieter Coeck," and this is confirmed by Coeck's biographer, Franciscus Sweertius, who says that Coeck "had a pupil, the painter Pieter Bruegel, to whom he gave his daughter in marriage." This statement is generally accepted and some have sought to corroborate it by pointing to alleged traces of Pieter Coeck's decorative

style in Bruegel's work. But these resemblances are dubious at best. Indeed, in a general way, it may be said that when art criticism uses suppositions of this order to bolster up some preconceived hypothesis, it tends to lose its authority and dwindles into mere verbiage. Yet Charles de Tolnay is almost the only writer on the subject who declines to see traces of any such influence in Bruegel's art. All the same, we cannot follow him when he goes on to use this as an argument against the reliability of Van Mander's account of Bruegel's life. On the contrary it helps us to understand the psychology of the youthful artist, both the precocious maturity of his talent and the uncompromising independence of his character. For a young man needed a strong, decided personality of his own if he was to stand up to the ascendancy of a teacher so gifted as Pieter Coeck, a copious (if rather prolix) painter, a man of wide-ranging knowledge, a very fine scholar, translator of the treatises on architecture of Vitruvius and Serlio, himself an architect and a highly esteemed designer of tapestry cartoons. All Coeck's work was imbued with the Italianizing formalism then considered the acme of good taste. At most one may perhaps be justified in seeing the influence of the tapestry designer in the markedly vertical structure of Bruegel's earliest large-scale compositions, *Netherlandish Proverbs*, *Carnival and Lent* and *Children's Games*. Similarly some authorities believe they can account for the topographical precision of his larger landscapes by the fact of his being a close friend of Ortelius, that "learned and admirable mathematician who with much honor to himself and to the satisfaction of all has figured forth the Theater of the entire terrestrial globe." But analogy hunting of this kind, however ingenious, seems of little real service for an understanding of the artist. We probably do better to dispense with such theories, based as they are on vague resemblances, and to view the artist's oeuvre in a broader context, capable of showing how far it was conditioned by the spirit of the age he lived in and contemporary problems.

It is greatly to be regretted that Van Mander fails to specify the exact date when Bruegel came to study under Pieter Coeck. The first

period of Coeck's brilliant but very brief career was spent in Antwerp. Brother-in-law of the painter Jan van Amstel, he married a famous miniature painter, Mayken Verhulst after the death of his first wife. In 1544 there began a new phase of his life, when he was summoned to Brussels to take over the post of the court painter Bernard van Orley, who had died in 1541. This did not, however, lead him to sever his connection with Antwerp, and when and where he enrolled Bruegel as an apprentice remains an open question. Did he do so at Antwerp, before 1544, or at Brussels? In other words, did Bruegel go to Brussels before settling in Antwerp? In any case—Van Mander is once more our informant—he went to work in the studio of the Antwerp master, Hieronymus Cock, after the untimely death of Pieter Coeck (which took place on December 6, 1550). It is quite possible that Bruegel was a member of the group of two hundred and thirty-five artists who in the previous year, under Coeck's supervision, had made the decorations of the City of Antwerp for the visit of Charles V and his son Philip.

In short, we may well believe that the young painter fell under the spell of the "City of the Seven Gates" in the course of his stay there. Antwerp was now a flourishing international and cosmopolitan center, a focal point of world trade and, as Guicciardini described it, "the common fatherland of all the Christian nations." While Bruges, stronghold of a defunctive conservatism, was losing its pre-eminence, Antwerp, greatly daring, had cast off the shackles of a parochial economy and given free play to the new forces of capital and private enterprise. German, Italian, Spanish and Portuguese businessmen, immigrants from all the dominions of the Emperor Charles V, had settled in the city where they now could benefit by the most complete commercial freedom and the most fully developed economic system of the age.

"Indeed," Guicciardini goes on to say, "it is wonderful to see such a concourse of men of so many different humors and qualities; and still more wonderful to come on such a variety of languages so different

from each other, so that without traveling abroad you can observe in a single town (and, if you so desire, imitate exactly) the ways of living and customs of diverse distant nations." So typically middle-class was the social climate at Antwerp that few of the nobility deigned to reside there. Nonetheless the citizens lived luxuriously, "perhaps more so than good sense would justify. At every hour of the day there are banquets, weddings, dances and sundry entertainment. In every street you can hear the sound of musical instruments, songs and merry-making. At every turn, in fact, you find tokens of the wealth, the pomp and power, and the splendor of this fine, most eminent City." Moreover, the Antwerp merchants showed "a well-nigh unbelievable activity in buying and selling, and warehousing commodities of all descriptions."

Alongside a busy traffic in oriental spices, grain from the North, French wines, German metals and English cloth, there developed an equally busy and prosperous picture market, stocked with works of art of all sorts and sizes hailing from every part of Europe. To begin with, the scene of its activities was the "Kerkplaats," near the cathedral; when the space available there proved insufficient, the market was transferred in 1540 to an upper floor of the New Stock Exchange. Guicciardini says that works were often purchased there "sight unseen," before delivery, and whole cargoes of pictures were assembled on the premises for shipment to Spain. Of the painters, engravers, sculptors and others supplying the Antwerp market with their wares some three hundred had qualified as "masters," and as such been granted official licences for the sale of their productions. Antwerp was also famed for its printing works; not only were more than half the books published in the Low Countries printed there, but it had become, like Paris and Frankfort, the center of a thriving trade in prints. Those published by Georg Hoefnagel, Willem and Hans Liefrinck, Philipp Galle, Hendrick Goltzius, Gerhard de Jode, the Wierixes and others were exported en masse to Italy, Spain and France and in even greater numbers to Spanish America. Meanwhile the same dealers—hard-headed businessmen as well as patriots—were importing quantities of engravings of Italian and

German provenance. This new development had an influence on the evolution of the Renaissance in the North equaling, to say the least, that of the printed book.

Among the pioneers of the movement the most enterprising was undoubtedly Hieronymus Cock, a painter and a highly expert copperplate engraver. No sooner had he won admission to the Guild of St. Luke (in 1546) than he went to Italy, staying from 1546 to 1548 in Rome. A lengthy mention of Cock in the *Lives* testifies to Vasari's high regard for him. What he saw in the Roman print shops and the establishments of the great publishers of prints—Antonio Lafreri, Tomaso Barlacchi, Antonio Salamanca, Claudio Ducceti and Giacomo Rossi—made him realize the enormous possibilities of this new industry. As a result, on his return to Antwerp, he decided to launch an enterprise of the same type on his own account. Accordingly he founded a publishing house near the New Stock Exchange, at the corner of La Courte rue Neuve and the Rempart Sainte-Catherine, giving it the auspicious name of "In de Vier Winden" (the Four Winds). And before long his establishment became the rallying point of the best artists of the day, headquarters of a brilliant school of engraving, and a favorite meeting place of the intelligentsia. Henceforth the "House of the Four Winds" was to share the Europe-wide prestige of Plantin's famous "Golden Compass." When we remember that Cock's father had taken the lead in making Hieronymus Bosch's art known in Antwerp; that one of Hieronymus Cock's earliest ventures was to have engravings made of the works of that brilliantly original genius and thus bringing them to the notice of a wider public; and, finally, that this great publisher's program evidences a desire to strike a judicious balance between the creations of local artists in the popular tradition and those of the Italian masters—when we bear these facts in mind, there can be little doubt about the part played by this milieu in the shaping of the Bruegelian *ars poetica*. Though no great stress need be laid on the fact that Bruegel is certain to have met the Mantuan engraver Giorgio Ghisi at the "Four Winds," it is highly

INTER VTRVMQVE VOLA, MEDIO TVTISSIMVS IBIS.

Qui fuit ~vt tutas agitaret Dædalus alas? Nempe quod hic altè, demissius ille ~volabat:
Icarus immensas nomine signet aquas? Nam pennas ambo non habuere suas.
Petrus Breugel fec: Romæ A: 1553.
Excud: Houf: cum priu: Cæs:

Georg Hoefnagel:

*River Landscape
With the Fall of Icarus,
1553. Etching.*

*River Landscape
With the Rape of Psyche,
1553. Etching.*

ARTI ET INGENIO STAT SINE MORTE DECVS.

Pulcher Atlantiades Psychen ad Sydera tollens, Ingenio liquidum possum conscendere Cælum,
Ingenio scandi Sydera posse docet. Si mundi curas fata leuare velint.
Petrus Breugel fec: Romæ A:1553.
Excud: Houf: cum priu: Cæs:

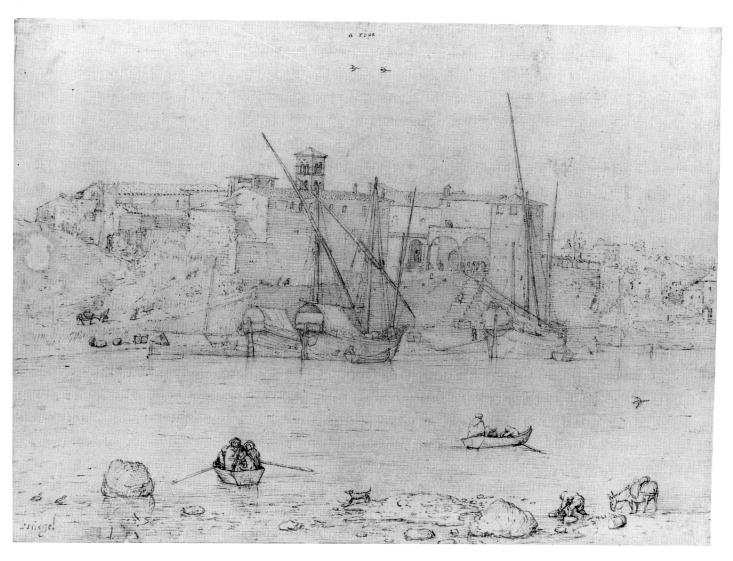

The Ripa Grande in Rome, about 1553. Drawing.

probable that this encounter strengthened his desire to make the usual
"pilgrimage to Italy"—which we may well imagine was proposed to
him in the first instance by his employer. In that case, it may also be
surmised that Hieronymus Cock asked his young assistant to carry out
some artistic or commercial research work while in Italy.

However this may be, it is certain that in 1553 Bruegel was in
Rome. This is proved by two etchings inscribed *Petrus Bruegel fecit
Romae A° 1553*, and here again we have a confirmation of one of Van

Mander's statements. These are two landscapes of the panoramic type in the tradition of Patinir and his followers. To them may be added a much finer work which, though undated, is signed *Bruegel* and inscribed *a Roma*. This, a pen drawing of the *Ripa Grande* (in Rome), now in the Duke of Devonshire's Collection, Chatsworth, is a work whose vibrant calligraphy premises a sensibility of a quite exceptional order.

It is from Rome, again, that we glean some information regarding Bruegel's painterly activities at this time. In the catalogue, dated June 22, 1668, of the Collection of J.B. Borrekens at Antwerp is an entry: "fragment of a picture painted by Bruegel at Rome" (see J. Denucé, *Les Galeries d'art à Anvers aux XVIᵉ et XVIIᵉ siècles. Catalogue*). This entry is of much interest, historically speaking, since it informs us of the young artist's earliest ventures in the field of painting. He must have already given proof of quite unusual talent and technical proficiency for him to have attracted the attention of Giulio Clovio, the famous miniaturist whom Vasari described as *un piccolo e nuovo Michelagnolo*. From the inventory of Clovio's estate we learn not only that Bruegel collaborated with him on occasion but also that he presented his Italian friend with at least three of his works, listed as *Una torre di Babilonia di avorio di mano di Mro Pietro Brugole*; *Un quadro di un albero a guazzo di Mro Pietro Brugole*; *Un quadro di Leon di Francia a guazzo di mano di Mro Pietro Brugole*: i.e. a *Tower of Babel* on ivory, a picture of a tree in watercolors and a view of Lyons, also in watercolors. Clovio's will (December 27, 1577) also mentions these works, all of which unhappily are lost.

It was not due to chance that Bruegel took to miniature painting when in Rome. He must have had many opportunities of learning this technique, since Pieter Coeck's wife, Mayken Verhulst, was a highly proficient miniaturist. So here we have an indirect confirmation of the fact of Bruegel's apprenticeship to the great Flemish decorative artist.

Bruegel, it would seem, turned out a vast quantity of work during his stay in Italy, mostly in the form of drawings and engravings. The

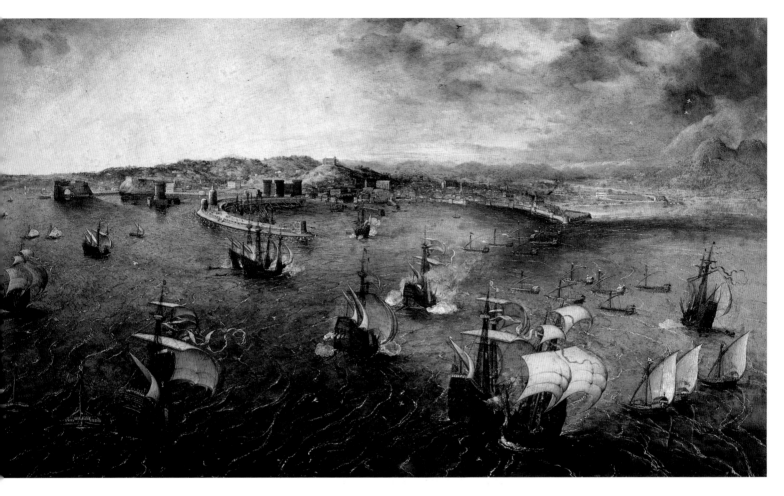

The Harbor of Naples, 1558.

hasty sketches in which he recorded his day-to-day discoveries of the Italian scene provided him with a fund of first impressions, dashed off in the rapture of the moment, on which he was to draw all his life long. There can be no doubt that what most quickened his youthful sensibility and delighted his eye was far less the hallowed vestiges of the past than the natural beauties of the southern landscape. His thirst for new visual sensations and his indefatigable curiosity led him to explore the furthest south of Italy. Gustav Glück discovered a view of Fondi (Private Collection, U.S.A.), a small town midway between Rome and Naples. That Bruegel visited Naples is proved by that famous picture, the *Harbor of Naples* (Galleria Doria, Rome). Though it is

View of Reggio di Calabria, about 1559. Drawing.

The Roadstead of Antwerp, about 1550. Drawing.

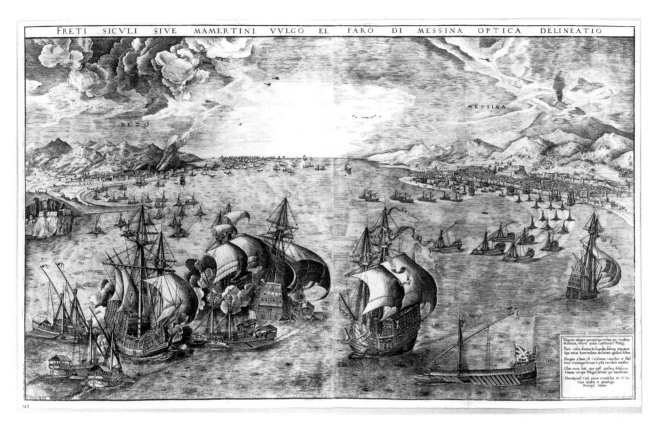

Frans Huys: Sea Battle in the Straits of Messina, 1561. Etching.

unsigned, its resemblance to his drawing of the *Roadstead of Antwerp* (c. 1550, Courtauld Institute Galleries, London) is unmistakable.

Next we find our painter in Calabria, where he made the drawing *View of Reggio* (Boymans - van Beuningen Museum, Rotterdam, formerly in the Koenigs Collection), a delightful work where the fine, nervous, pointillist pen-strokes are supplemented by touches of lightly applied color, added later and said to be the work of Claude Lorrain. Here we have undoubtedly a preliminary study for that remarkable composition, the *Sea Battle in the Straits of Messina* of which, in 1561, Hieronymus Cock had an engraving made by the highly expert etcher Frans Huys. The composition is so skillfully built up touch by touch and to it the artist has evidently devoted so much loving care that we are fully justified in believing that in its original form it was a large-scale painting, all trace of which has been lost. Linking up with the

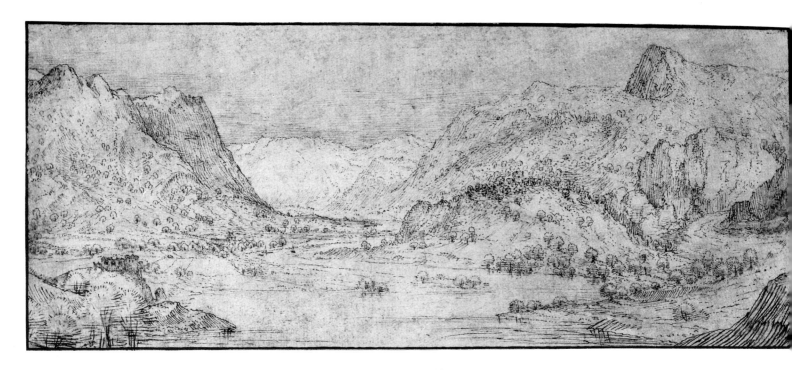

Valley and River (The Ticino Valley), 1554-1555. Drawing.

striking series of *Ships of the Sea* (also engraved by Frans Huys from drawings made in Sicily), this print, an exceptionally large one, has a documentary interest: that of recording a dramatic naval engagement in the Franco-Turkish struggle for supremacy in the Mediterranean. Also, it marked the beginning of a genre of painting (hitherto confined to miniatures) that was brought to fruition and standardized in the following century by the Dutch painters Bakhuysen and Willem van de Velde. (An intermediate stage in the development of the genre can be found in an album of sketches—in the Bibliothèque Royale, Brussels—several of which quite clearly stem from Bruegelian sources.)

Bruegel seems to have followed an oddly circuitous route on his journey to Rome. The mention of a view of Lyons in the inventory of Clovio's estate is held to be proof that he visited that city on his way. Thence he presumably followed the Rhone valley, stopping at Geneva, before tackling the arduous crossing of the Alps. Resemblances have been traced between certain localities in the Rhone valley and the

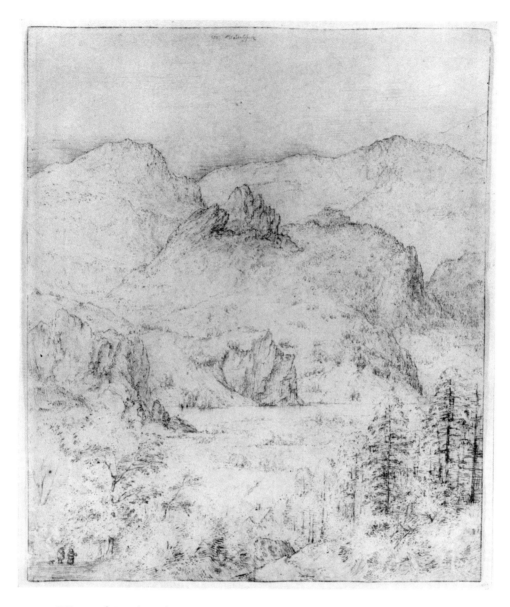

View of Waltensburg ("Waltersspurg"), about 1554. Drawing.

landscapes of *Hunters in the Snow* and the *Magpie on the Gallows*. Also, the landscape of the *Harvesters* (Metropolitan Museum, New York) might well be a view of Geneva seen from the village of Archamp; the profile of the mountain range in the far distance, the indentations of the lake and the general layout of the plain are remarkably like the view one has today from the foot of the Salève (a mountain near Geneva).

Finally, in the famous "Large Landscape Series" engraved, it seems, by Cock in 1555, Louis Lebeer claims to have identified Mont Salève, some of the Savoy mountains, a view of Chillon, the countryside between Aigle and Bex, Mont Catogne and the Dents-du-Midi.

A drawing of the *Ticino Valley* (Dresden), the mention of a lost picture, "Mount St. Godard (*sic*) by Bruegel the Elder," in the Rubens Collection (Denucé, *op. cit.*) and a drawing inscribed *Walterrspurg* (at Bowdoin College, Brunswick, Maine) which Otto Benesch has identified as a view of Waltensburg in the Canton of Grisons, Switzerland, give some further clues to the wanderings of this singularly erratic traveler. Lastly, mention may be made of a sketch (in Berlin)

Mountain Landscape, 1553. Drawing.

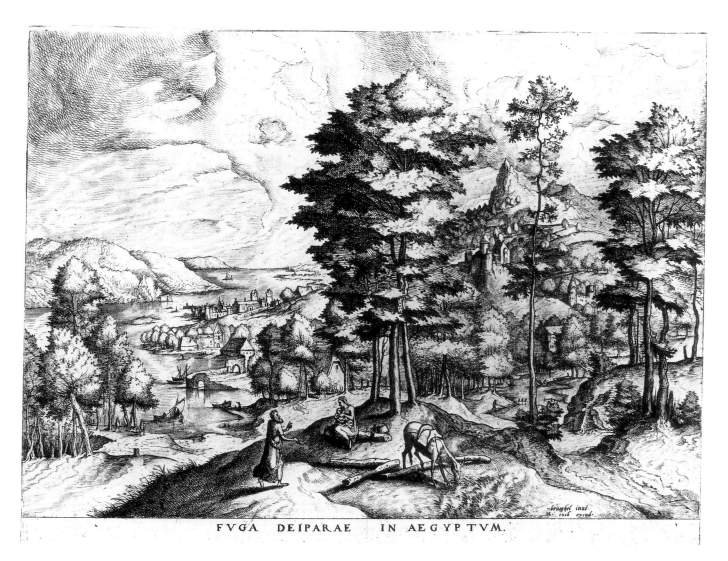

FVGA DEIPARAE IN AEGYPTVM.

The Flight into Egypt.
Etching from the "Large Landscape Series," about 1553.

which has been thought to represent the Martinswand, a mountain near Innsbruck, but its authenticity is too doubtful to warrant the assumption that Bruegel also visited the Austrian Tirol.

Relatively little is known about the personal contacts made by the artist during his Italian sojourn. Besides striking up a friendship with Clovio, he made the acquaintance of the geographer Scipio Fabius in Rome or Bologna. Evidently the two men took to each other, since some years later in a letter dated June 16, 1561, to Ortelius, Fabius asked

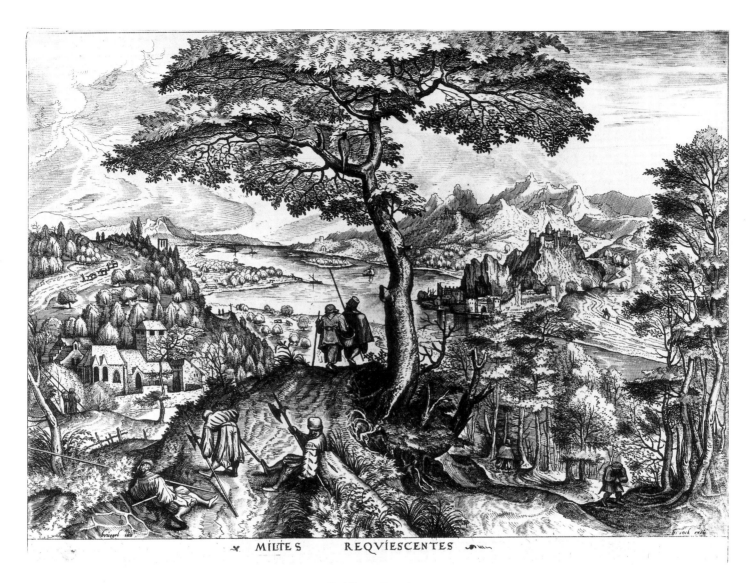

Soldiers Resting.
Etching from the "Large Landscape Series," about 1553.

for news of his "very dear" friend "Petrus Bruochl." And again, on April 14, 1565, Fabius requested Ortelius to convey his friendly greetings to Bruegel. Reference is also made in these letters to the Antwerp painter Martin de Vos; this has led to a surmise (dubious at best) that the two men joined forces for a part of the journey.

Traveling was an exceedingly slow business in those days, set to the tempo of a day's ride on horseback, and Bruegel's return journey was

delayed not only by the difficult country he had to cross but by the movements of armies on the march and sometimes engaged in conflict. At long last "Maestro Pietro Brugole" safely found his way to Antwerp, where we next hear of him in the employ of Hieronymus Cock, at the end of 1553. He collated his travel notes, readied for engraving his "Large Landscape Series" and signed in this same year the first dated painting that has come down to us, the *Landscape with Christ appearing to the Apostles* (Private Collection).

Alpine Landscape With Deep Valley.
Etching from the "Large Landscape Series," about 1553.

It would seem that for the next four or five years his painterly aspirations were seriously hindered by his activities as a designer for engraving. Under his contract with Cock he was restricted to subjects appealing to contemporary taste, works that could be reproduced in large numbers and catered for the widest possible public. His task was concisely to interpret and to present in visual form and the most telling manner the popular conceptions of the day, in particular the "diabolic" iconography of the great Hieronymus Bosch. But these obligations, due to commercial exigencies and the taste and fashion of the age, were a blessing in disguise since they made constant demands on his imagination and encouraged him to test out his creative powers to the full. No less stimulating must have been his daily contacts at the "Four Winds" with artists of all tendencies, men of letters, intellectuals, dealers and collectors: contacts which go far to explain that "universal" quality which was to be a striking feature of his culture.

As for his political and religious opinions, these can doubtless be gauged by his intimate relations with two distinguished men of the day, Hans Franckert and Christophe Plantin. Connoisseur and merchant, poet and patron of the arts, and a member of the Chamber of Rhetoric named "The Violet," Franckert was an active member of the "Four Winds" circle. A native of Nuremberg, he had migrated to Antwerp owing to his sympathies with the Reformation movement. He was one of Bruegel's first buyers and the frequency and regularity of his commissions must have had a beneficial effect on the artist's productivity. The two men were firm friends. Van Mander tells us that "they often went out into the country to see the peasants at their fairs and weddings. Dressed up as peasants, they brought gifts like the other guests, claiming relationship with the bride or groom." But they could not have got on so well together had they not had many traits in common besides this taste for rustic junketings, and we may assume that they had similar ideas on the problems of the day.

Bruegel's intimacy with Plantin is well known. Like Hans Franckert, Plantin made no secret of his sympathies with the Reform

movement, dangerous as these were. In 1563, having been denounced as belonging to a clandestine sect, he had to flee from Antwerp; this, as it so happens, was also the year when Bruegel left that city and married at Brussels. It has been suggested that he, like his friend, had become involved in some "heretical" movement, and used the wedding as a pretext for moving to a safe distance from potential persecution. Since the circle he frequented seems to have been limited to men of the "Libertine" persuasion, we may draw conclusions as to his own views on such matters and in any case, as we shall see, there are clear indications in his later work that he regarded himself as a "committed" artist. But allowance should also be made for the fact that the financial situation at Antwerp was deteriorating, and this, too, may have prompted him to welcome proposals made by members of the wealthy upper middle class of the "Prinselijke Stad," which was now the political heart of the Low Countries and stepping into the place of Flanders as the arbiter of public opinion. Moreover, as Van Mander tells us, he was courting Mayken, the daughter of his first teacher, Pieter Coeck, at the time and his future mother-in-law was in business in Brussels as an art dealer. According to Van Mander her consent to the marriage was conditional on Bruegel's coming to live in the capital of Brabant "so as to give up and put away all thoughts of his former girl (at Antwerp)." Needless to say, this sentimental reason for his move to Brussels does not necessarily mean that there were not other motives as well, both of a practical order and due to his distaste for the social climate of Antwerp.

The marriage was solemnized in the summer of 1563, in Notre-Dame-de-la-Chapelle, parish church of an ancient working-class district largely inhabited by weavers. This is vouched for by one of the few scraps of documentary evidence dating to the painter's lifetime, the following entry in the marriage register of the church in question:

> *Peeter Bruegel*
> *-solmt*
> *Maryken Cocks*

It is generally believed that he lived in the house which now is No. 132 in the Rue Haute, at the corner of the Rue de la Porte Rouge. In the 17th century it formed part of the inheritance of his great-grand-son, David Teniers III. It was here that the great painter spent the last six years of his life, years of glory but also of horrified dismay when he saw scaffolds and gallows springing up on every hand, and the air was loud with the rattle of the Spanish musketry.

Two sons were born in that darkest period of the history of the Low Countries: Pieter known as "Hell" Brueghel in 1564 (?) and Jan known as "Velvet" Brueghel in 1568. Their father died with tragic suddenness on September 4, 1569, when he was working on a set of pictures that the Brussels City Council had just commissioned to commemorate the completion of the Brussels-Antwerp canal. He was buried near his studio, in the church of Notre-Dame-de-la-Chapelle where his marriage had been celebrated six years before.

That there was every indication of the recently deceased painter's spectacular rise to fame, was the gist of the reply sent by Provost Morillon to a letter from that highly cultured statesman and great art lover Cardinal de Granvella on December 9, 1572. "I sent Christian the painter to buy the xxv paintings on canvas in Antwerp . . . but you must count on having to pay heavily in order to recover the pieces by Bruegel." (The archiepiscopal palace at Malines had recently been sacked, in the troubles of 1572.) "Since his death his works are more sought after than ever and they now fetch 50, 100 or 200 crowns."

THE MEASURE OF ALL THINGS

NATURA NATURANS

> I hold that by *natura naturans* we should mean that which exists in itself and is conceived in itself, in other words such attributes of substance as express an eternal, infinite essence.
>
> SPINOZA

THE history of Western civilization is far from being all of a piece. Rather, it consists of a series of well-marked phases, a variety of cultural patterns within which the concepts of time and space have undergone far-reaching modifications. Stemming from a complex of interrelations in which science and economics, art and technique, society and the individual, thought and the imagination, reciprocally act upon each other, these modifications reflect, express and illustrate successive changes in the relations between man and society, between man and nature, between man and the universe. These relations are fundamental to the human situation, and determinants of men's outlook on the world in any given period. Thus they involve not only certain habits of thought and ways of seeing but also (as a result of these) certain trends of the creative process. And, finally, they provide fixed criteria that condition, shape and orient the "period" sensibility.

Here begins the work of art: a direct emanation from sensory experience to begin with, but also the expression of an attitude towards

the world, "an image of our relationship with nature." Thus the work of art is at once one and multiple, and its unity is apprehended only at the intersection of a great diversity of viewpoints. We need also to extricate it from the rubble of archeology, from the anatomy of styles and the side issues of erudite analysis. Above all, we need to attune as best we can our modern sensibility to the sensibility which fecundated the work of art at the time of its conception. If this were truly feasible, what a wonderful new world would open up before our eyes! However, unfortunately our data are lacking and inadequate to furnish a method of approach so stimulating and rewarding. We can only hope that future historians will accumulate the materials needed for a "history of sensibility" through the ages. Then and then only will our understanding of works of art acquire a new dimension and we shall be able to avoid the too widespread tendency to assimilate the vision of the past to our times.

All is in everything; nothing is isolable from the whole. And since implicit in any given fragment, however small, of a completed work is the vibrant life infusing the composition as a whole, the magic power of a detail can never play us false. Take for example this *Thistle*, seen in isolation from the vast, elaborately constructed picture to which it belongs (the *Procession to Calvary*, Vienna, 1564); how well this minor detail summarizes and symbolizes the conception permeating the entire work! Broadly painted, with an amazing sense of tactile values, it reveals the mystery of all plant life. It brings before us, in its stark visual actuality, the essential nature of this thick-leaved, spiky plant, flaunting, one would say, its malevolence to man. But in so speaking we are falling into a common error, and keeping to a critical tradition that should, by now, be obsolete. For it is not the thistle as such that fascinates us, but the element of the human implicit in it, that is to say its revelation of a visual experience and its testimony to a certain state of mind. Seen thus, it is not a mere plant but an upcrop from the deeper strata of consciousness, a transparent symbol summing up the world view of the epoch.

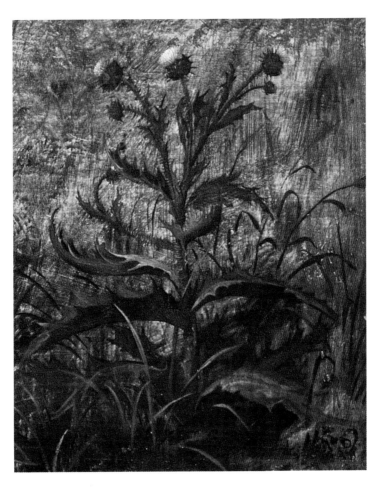

The Procession to Calvary, Detail: The Thistle, 1564.

In that period of unbridled curiosity the vogue for herbals and maps had opened up new fields of interest. And similarly the vogue for automatons pointed the way to the coming of the machine age. Meanwhile, however, time flowed lethargically on—the "man in a hurry" was as yet unborn. Between its far-flung seacoasts Europe was crossed on horseback or in carriages at an average rate of thirty miles a day. Clocks were just coming into general use, breaking up the flow of organic time—chiefly with a view to fixing the hours of fairs and markets—and introducing an abstract reckoning soon to adjust men's daily lives to a new rhythm. But, as yet, it was the rhythm of nature that prevailed; even within city walls it was the crowing of cocks that

announced the hour of waking. After nightfall all was darkness, all was silence, except when the townsfolk were indulging in a festival or music-loving merchants organized a concert. Many discoveries were made, but technology did not advance *pari passu*; water, wind, draught animals were, as they had been since time immemorial, the only sources of applied power. In short "natural conditions" still set the tempo of human activities.

Devoid of any logical structure and always ready to endorse the supernatural, the thought of the day made but desultory appeals to Reason. Mathematics was now in the ascendant, pointing the way towards a quantitative mentality. After being applied to the measurement of time and yoked to the service of commerce, it now applied a yardstick to indeterminate space that was henceforth to supersede the approximations of the artist's eye. Subjected to its disciplines, that eye at last could marshal appearances in a precisely calculated order and impose on them a rigid hierarchy. Mathematical perspective at once provided the artist with a countercheck on his imagination and, in furthering a cosmic sense of space, inaugurated a new relationship with the outside world giving rise to a whole philosophy of nature. Based on an intensive study of the structure of Nature-in-herself, this method of research culminated in an image corresponding to the world-picture formulated by the natural philosopher, the concept of an infinitely extended, eternal universe, inseparable from its Maker, a concept which was now so solidly established that it remained unchallenged until the end of the 19th century.

It fell to Bruegel to implement this new and ampler measure of the universe in his art. Between the landscape dated 1553 (Private Collection, cf. de Tolnay, *Burlington Magazine*, August 1955) and the *Storm at Sea*, his last known work (1568, Vienna), two intermediate pictures admirably illustrate the transition from the qualitative to the quantitative. These are the *Parable of the Sower* dated 1557 (The Timken Art Gallery, San Diego, replica in the Prado) and a *Temptation of St. Anthony* (National Gallery, Washington). They seem to have been

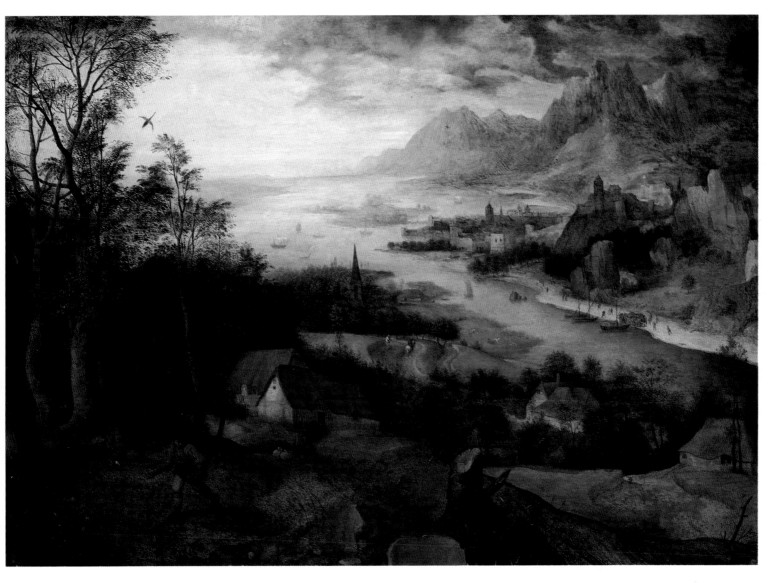

The Parable of the Sower, 1557.

painted at about the same time, that is to say soon after Cock's publication of the "Large Landscape" series of prints. The layout of the first-named picture is clearly based on that of the etching *Resting Soldiers* (*Milites requiescentes*, Bastelaer, No. 17), and the second, while keeping the rhythm of the print *S. Hieronymus in Deserto* (Bastelaer, No. 7), recalls certain details of an engraving in the same series, *The Flight into Egypt* (*Fuga Deiparae in Aegyptum*, Bastelaer, No. 15).

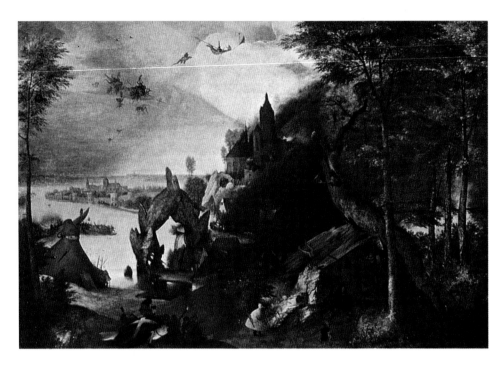

The Temptation of St. Anthony, about 1558.

Foreshadowed by Patinir, the new sense of the organic relationship between man and his environment is given here its fullest possible expression. It underlies the structure of the *Weltlandschaft* ("world landscape"), as Ludwig von Baldass aptly names it, and also indicates a visual approach perfectly adapted to the then widespread desire for knowledge.

In Bruegel's truly superb renderings of the visible world, all conspires, as Valéry might have said, to implement the satisfying effect produced on us by these "semi-natural" landscapes: clarity in the treatment, dynamic contrasts, modulations of the light and a brilliant unity of viewpoint. If we call them "semi-natural," this is only because they associate within the same spatial context, always with perfect coherence, a cottage of the North and a Mediterranean sail, a Flemish belfry and a Calabrian stronghold, a Belgian hillside and an Alpine mountain range, the sodden turf of Flanders and the sun-scarred rocks of Italy, the gentle undulations of a meadow and the "accidental

statuary" of a rugged foreshore. Here the most searching individualist gaze is wedded to the "universalism" that was then the order of the day. We find a similar attitude in contemporary scientific literature; the writer often aims at combining in a single work the whole range of human knowledge; whether that work deals with jurisprudence, medicine, economics, or history. For whereas Bruegel, thanks to the sweep of his genius, succeeds in overcoming the disparity of motifs and in completely integrating a host of very different, often conflicting, data, the humanist writers were as yet unable to supply their readers with anything more than a mosaic of ideas and observations without co-ordination or connecting links. "It is not unusual," writes J. Ellul, "to find in 16th-century works on jurisprudence long disquisitions on archeology, theology, psychology or linguistics, not to mention history and literature. We find whole chapters devoted to the practice of magic or maybe Peruvian sociology intercalated in books dealing with high finance or the legislation of the Parliament of Bordeaux."

It is amazing to see in Bruegel's œuvre how the golden thread of a great painter's genius weaves its way throughout the complex pattern of contemporary thought; and how therewith he masters and surpasses it. Yet it is well, also, to recognize the fact that one of the reasons why Bruegel succeeded in endowing painting with a plenitude and a perfection unseen in the literature of the day was that he had a greater faculty than any of his contemporaries for evaluating the moral and material components of the age and for expressing himself wholly, unreservedly, through their intermediary.

Another remarkable feature of these landscapes—to which may be added that ingenious work the *Fall of Icarus* (Brussels, Musées Royaux des Beaux-Arts; another version in the Van Buuren Collection, Brussels) and a *Flight into Egypt* (1563, Courtauld Institute Galleries, London)—is that they are "composed" with such skill and with such a sense for near-musical effects, and so fluently and effortlessly executed, that we can well believe them to be veritable "slices of nature," directly experienced and apprehended. Here at last an artist has captured in the

meshes of the new optics the exact "feel" of ever-changing appearances, sensed the very heartbeats of Nature, and given free rein to a truly impressionist sensibility.

For Bruegel was essentially an open-air man, a lover of the windswept countryside of his native land, as well as a born landscape painter, and we feel this in all his work even when landscape is not the leading theme. True, there was then no thought of painting in the heart of nature; two centuries were to pass before artists had the notion of setting up their easels in open country. But the happy ease of Bruegel's

The Fall of Icarus, about 1558.

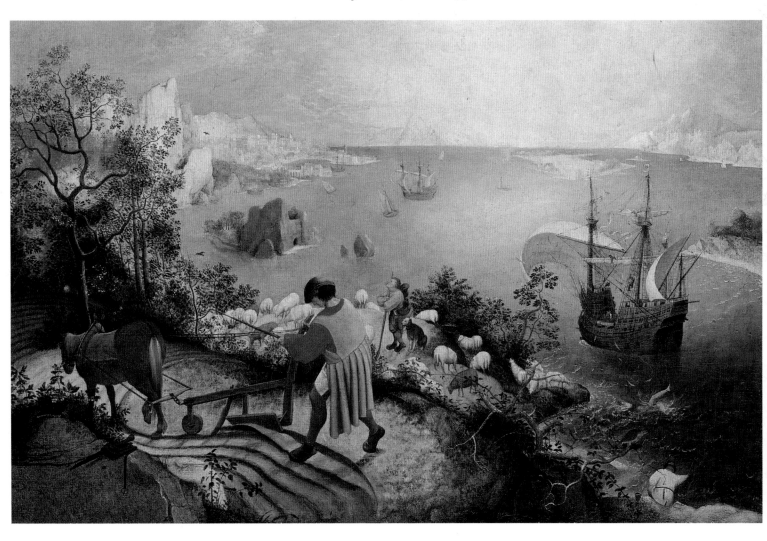

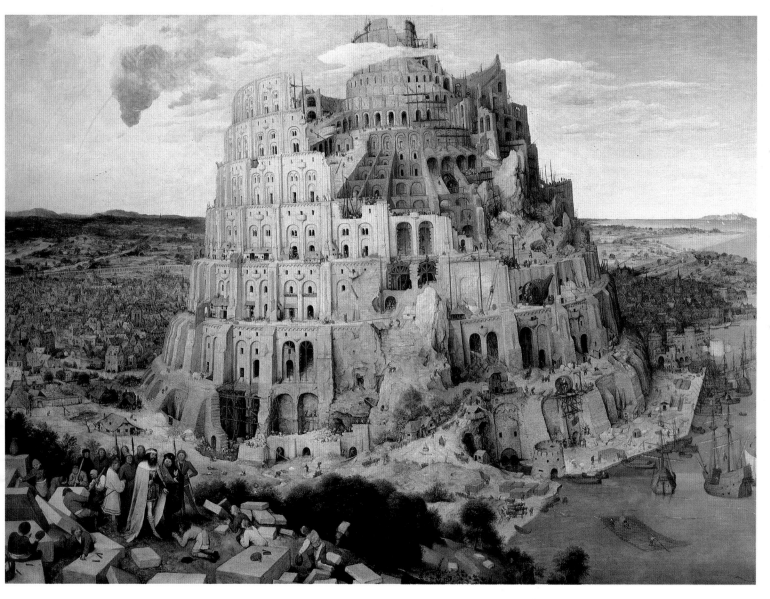

The Tower of Babel, 1563.

art and the relative truth-to-life of the Bruegelian syntheses are all the more remarkable and precious for this very reason. Nor must it be forgotten that, studio compositions though they are, they are an assimilation of studies done on the spot, scrupulously accurate drawings made *naer het leven* (from the life) according to the analytic method introduced by Dürer and Leonardo. In them nothing is left to chance.

Such is the painter's skill that he submerges the framework—the bare bones—of the composition and the execution of the original drawings under a wealth of masterly brushstrokes, a fluent spate of color, lightly or thickly applied according as it conveys an illusion of space or substantiality, or else (as occasionally happens) is used to mask the emphatic diagonal which often strikes across the three traditional color planes (brown, greenish blue and a bluish grey sometimes flushing into pink, all discreetly modulated). And lastly, so as both to stress the asymmetry of his compositions and to add breadth to his panoramic views, Bruegel took to introducing—this was his personal invention—clumps of trees on the right- or left-hand side of the picture, which acted as taking-off points for the distribution of the light and the interplay of values throughout the composition.

Ortelius once declared that there was more thought than painting in Bruegel's works—a remark that did less than justice to the artist. True, so eye-filling are these mirrors of the visible, that they seem sufficient to themselves and conceived with but a single aim, that of humanizing nature. Thus it is all the more surprising to discover that underlying all is a motive that today we should style "literary," that all have a biblical or didactic referent and all are charged with a significance discreetly woven into the texture of the composition. The *Parable of the Sower* follows exactly the wording of the passage in St. Matthew; the *Fall of Icarus* illustrates a fable in Ovid's *Metamorphoses*; the *Temptation of St. Anthony* illustrates an episode of The Golden Legend. All three pictures contain a similar message and go to implement a single train of thought. We see birds pilfering the seed broadcast by the peasant; Icarus failing in his mad attempt to fly; the spirit of evil vainly assailing the hermit. Everywhere action is doomed to failure; and confronted by the inexorable logic of Nature, man learns the limitations of his lot on earth. "*Natura naturans.*" In vain that gigantic *Tower of Babel* (1563, Vienna) aspires to pierce the sky, never will it scale the zenith, and it remains a monstrous monument to the incorrigible vanity of all human pretensions.

EVERYDAY LIFE

THE TOPSY-TURVY WORLD

> Every time the world order and the social
> system are called into question this involves
> an overhaul of the résumés of ancient wis-
> dom embodied in the proverbs of the past.
>
> CLAUDE ROY

B RUEGEL's early drawings and early paintings alike, all dating to
the period between 1553 and 1558, reflected exclusively the
artist's responses to the natural scene: trees and plants, rivers,
plains and mountains, the ocean of the sky, the far-flung splendor of
terrestrial and maritime horizons. By and large they constituted a
full-fledged *ars poetica*, the fruit of daylong meditations, and seemed to
point the way towards a boldly experimental art culminating in pure
Impressionism.

It was due to Hieronymus Cock that Bruegel's course was tem-
porarily deflected from this path, and he abandoned poetry for prose,
solitude for collective life, nature for the theater of the world of men.

As early as 1557 he had begun, at the suggestion of the great
Antwerp publisher, a sequence of seven engravings illustrating the
Deadly Sins. Obviously their purpose was to inculcate a moral lesson.
They marked a turning point in his career, away from a technique all
in veiled suggestions to clean-cut linearism, adapted to engraving. Thus
he was called on to superimpose a more "philosophic" attitude on his

The Deadly Sins: Envy, 1557. Drawing.

The Deadly Sins: Lust, *1557. Drawing.*

The Temptation of St. Anthony, 1556. Drawing.

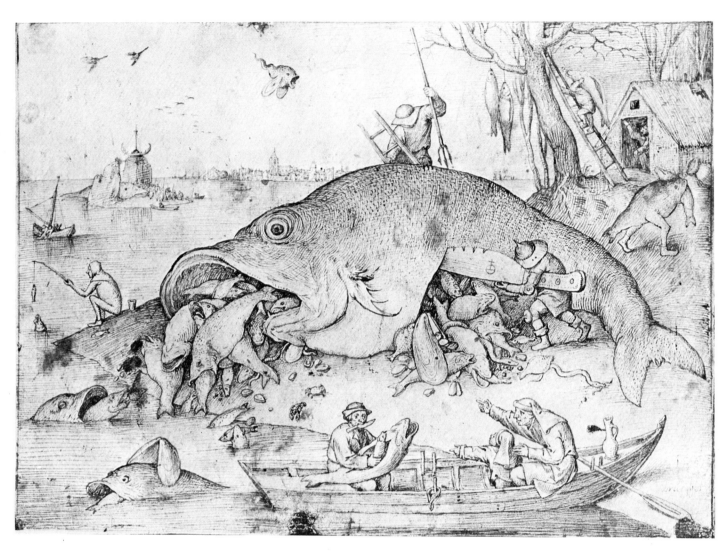

Big Fish Eat Little Fish, 1556. Drawing.

new, still tentative feeling for nature, and also to investigate and exploit the possibilities of illustrative painting.

Was Bruegel now to yield to literary, medieval, outworn tendencies, to the didactic pretentiousness of the rhetoricians, to the encyclopedic pedantry of the humanists? Was he to lapse into an anecdotal art and surrender to the pressure of tradition?

For if, as his publisher wished, he had to illustrate the disastrous consequences of men's vices and disclose the motives of their passions, two sources were available and these were bound to tinge his work with archaism and give it a faintly "old-world" air. On the one hand there was the demon-haunted world of Bosch and on the other, the copious, familiar repertory of current Netherlandish proverbs. The imagery of the Bois-le-Duc master—his hybrid monsters, obscene creatures, quaint *diableries*—fired Bruegel's imagination. The wit and wisdom of the proverbs appealed to his critical sense, gave scope to his inventiveness and a fillip to his skepticism. Amidst a horde of grotesque, artificial, ambiguous forms, poised in a sort of abstract never-never land, we find a directive idea taking shape, the germ of a new conception of life. The veiled allusions that work their way into the landscapes painted in this same year were not due to chance, but related to the problems that now preoccupied his thoughts. This relationship should be stressed, since it not only shows the adaptability of a highly flexible genius but—what is more important—accounts for the dialectical unity of his later work.

Also commissioned by his publisher was a second series of engravings (begun in 1558), the *Seven Virtues*, designed as a sequel to the *Sins*. But here there is a decisive change of tone. Bruegel has jettisoned the archaisms deriving from Boschian morphology. These pictures of men engaged in the multifarious activities of daily life called for a keenly observant eye, a ruthlessly objective vision. The allegory, the central theme around which the composition is built up, is merely a pretext for a vigorous depiction of the mores of the peasantry and townsfolk. In *Faith*, a masterpiece of its kind, Bruegel achieves a style. We see a

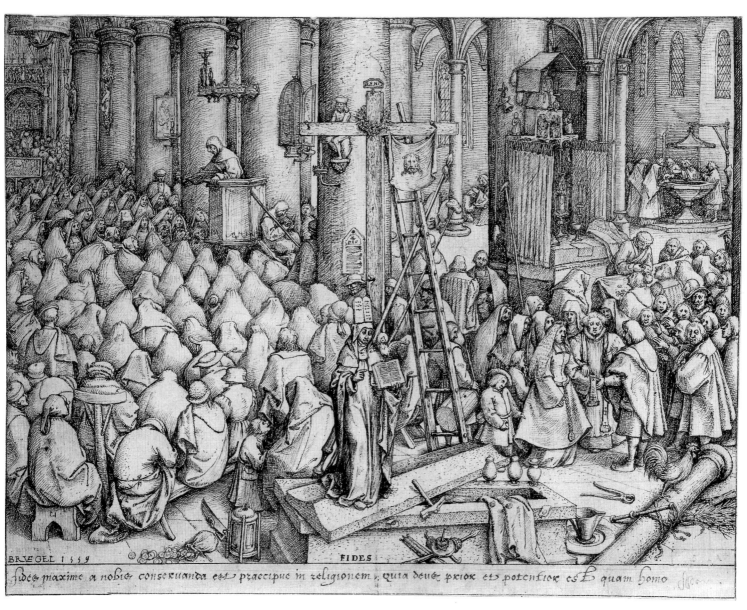

The Seven Virtues: Faith, *1558-1559. Drawing.*

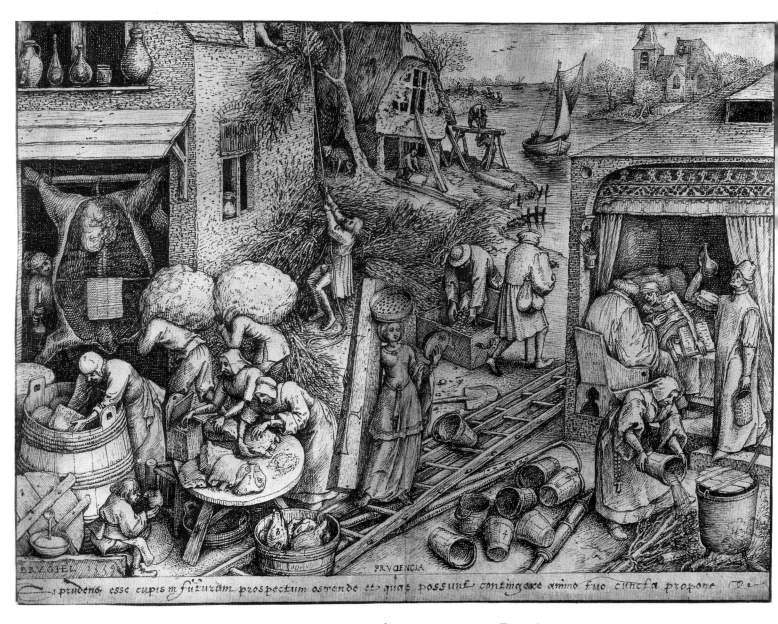

The Seven Virtues: Prudence, *1558-1559. Drawing.*

procession of cowled figures in the nave of a church, all presented in back view and given a single, basic attitude. The setting of *Charity* is a humble village and the central figure is surrounded by peasants of all ages, posed in picturesque, skillfully varied, realistic attitudes; whereas *Prudence* illustrates the homely activities of a housekeeper. By dint of close and constant contacts with reality Bruegel created a *type-figure*, perfectly realized from the very start, and distinctively "Bruegelian," broadbacked, short and sturdy, boldly modeled and fined down to essentials, whose elliptical structure gives only the faintest hints of the geometrical schema underlying it.

From every point of view these drawings are of capital importance. They prove that Bruegel had now formed a habit of thinking in terms of metaphor. He had plunged into the world of fables and proverbs, of the obsessions of the medieval mind and the unrest of the times. These works also led him to the use of close-knit, compact forms, lending themselves to bright, boldly stated local colors. Thus it was not due to chance that he now was led to create his first large-scale paintings based on popular themes. In 1559 he signed and dated two vast compositions: *The World Turned Upside Down* (Berlin), better known as *Netherlandish Proverbs*, and the *Fight between Carnival and Lent* (Vienna). In the following year he signed and dated *Children's Games* (Vienna). The three works have approximately the same format and were probably commissioned by his friend the merchant Hans Franckert with a view to decorating the walls of some stately mansion he possessed in Antwerp.

It would seem that in the same two years, 1559-1560, Bruegel painted two equally large panels in the same vein: *Kermess at Hoboken* and the *Joys of Skating*. Both unfortunately are lost, but we get an idea of them from two prints (Bastelaer, Nos. 205, 208). The same fate has befallen the *Witch of Malleghem* and *Madmen's Dance*; the engravings reproducing them (Bastelaer, Nos. 193, 195) show that the painter now was trying to introduce touches of real life into crabbed accounts of "Human Follies" compiled by the rhetoricians.

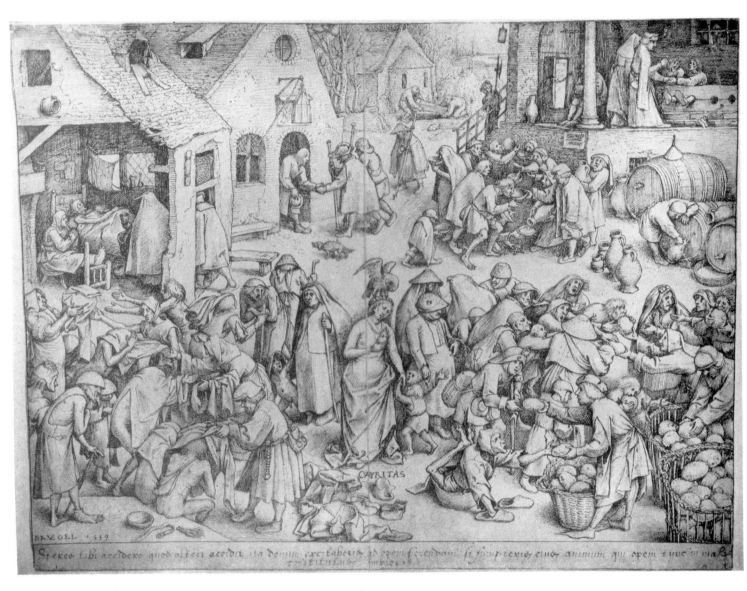

The Seven Virtues: Charity, *1558-1559. Drawing.*

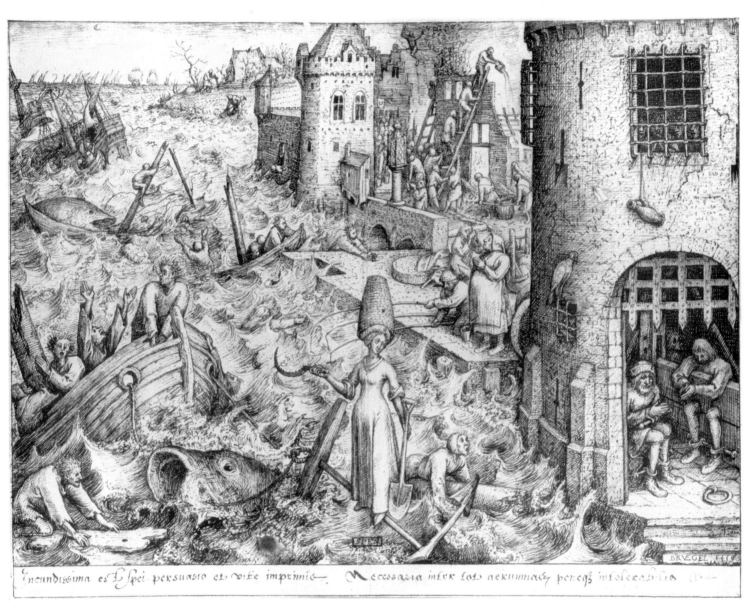

Incundissima eſt Spei perſuaſio et vitæ imprimis. Neceſſaria inter tot ærumnas pericq́s intolerabilia.

The Seven Virtues: Hope, *1558-1559. Drawing.*

The Berlin picture was the first, it seems, of this magnificent sequence. It consists of a pictorial anthology of at least a hundred proverbs, maxims and popular adages reflecting the customs, turns of speech and literature of the Netherlands. A host of figures, including village craftsmen and field laborers with their domestic animals, interpret faithfully each theme. The setting is purely arbitrary, the figures disport themselves on a flat plane, and there are only the faintest hints of perspective recession. The various scenes are treated separately, the only link between them being that of color, a systematic alternation of cool and warm tones. Each of the figures goes his way as if unaware of the others' presence. We see a man winnowing feathers in the wind —an allusion to the saying *want pluymen in den wint*; another seated on ashes between two stools, *tusschen twee stoelen in d'assen sitten*; another trying to knock down a wall by ramming it with his head, *met den kop tegen den muur loopen*; another swimming against the stream; another carrying light in baskets, in broad daylight; and yet another gnawing at a church pillar, while a half-wit makes his confession—to the devil! Lunacy at large, perhaps, but there is a common measure of these follies; all these people are struggling, vainly, to defeat logic, fighting to no avail against the scheme of things. In the center of the composition is a group to which the artist has evidently devoted special attention and which epitomizes all these manifestations of human folly. Here the figure of a young woman in a stylish red dress, falling in Gothic folds, strikes a contrast with the "proletarian" atmosphere of the rest. To prevent her husband, a lame, tottering oldster, from seeing her infidelities, she is wrapping a big cloak with a projecting peak, the "Blauwe Huyck" around him.

Foukens die geern hier en daer den offer ontfangen
Moeten haer mans de blau huycke omhangen.

The woman who gladly welcomes favors here and there
Must hang the Blue Coat round her husband.

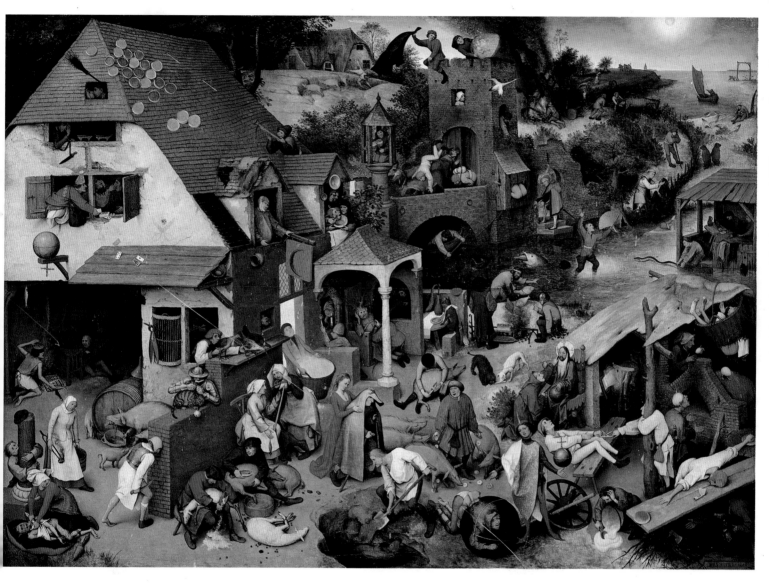

The Blue Cloak (Netherlandish Proverbs), 1559.

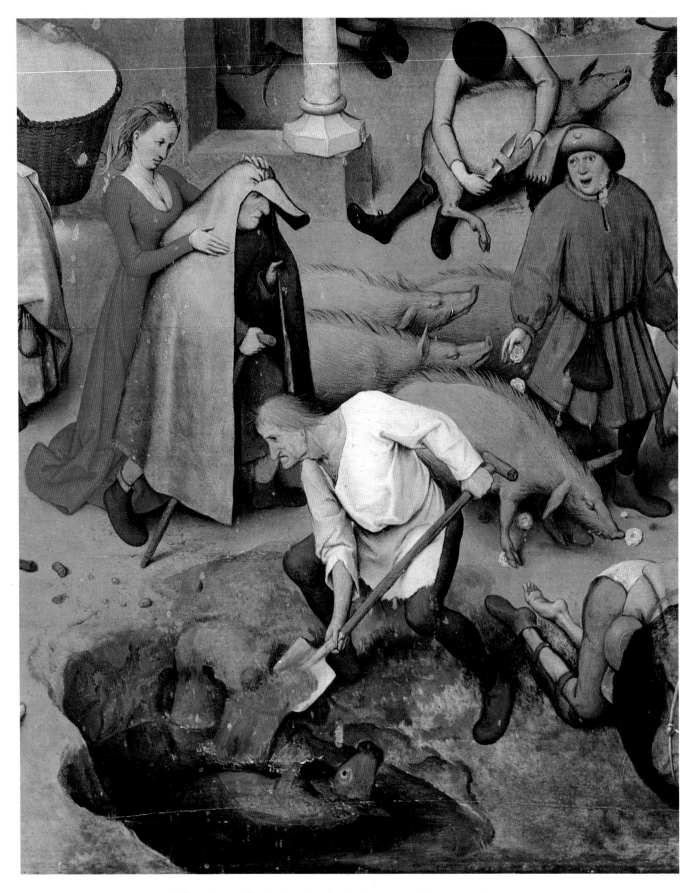

The Blue Cloak (Netherlandish Proverbs), Detail, 1559.

These lines figure under the same group in an engraving by Jan van Doetechum (Joannes a Doetinchum) published at Antwerp in 1577, in which the text of each proverb accompanies the scene illustrating it. Thus it has been of help in deciphering Bruegel's "picture puzzle." It also has an overall caption:

> *De Blauwe Huycke is dith meest ghenaemt*
> *Maer des Werelts Idel sprocken hem beter betaemt.*
>
> The Blue Cloak is this picture's usual name, but better would be "the Follies of the Topsy-turvy World."

A fragment of an etching bearing Frans Hogenberg's monogram and exactly contemporaneous with Bruegel's work was discovered in the Berlin Kupferstichkabinett by Louis Leeber. It has the same synoptic layout, with illustrations of twenty-one proverbs, each with its "legend," grouped around the woman "covering her husband with his flowing cloak." Moreover, the title of the etching (part of which is lost) was, in its complete form, identical with that of the Van Doetechum print. Finally, the fact that an engraving made at Antwerp in the 18th century and inspired by the same theme is titled (in French) "A True Portrayal of the Follies of the World Turned Upside Down" throws additional light on the meaning of Bruegel's enormous picture. The "Blue Cloak," psychological, structural and chromatic center of the composition, is an emblem of the folly of a world gone crazy. A folly that the painter neither censures nor commends. He contemplates the antics of his figures with a sardonic smile and tolerant disdain.

In the *Blue Cloak*—it is to be hoped that this more correct title of the so-called *Netherlandish Proverbs* will be adopted—Bruegel, who was grappling for the first time with the problems of a large-scale work, could not entirely cope with its thematic complexity. Not only do the forms still lack concision and often seem a trifle clumsy, but the piecemeal composition and profusion of details tell against a true organic unity.

In the *Fight between Carnival and Lent* these lapses are eliminated. The magical power of color triumphs over a plethora of anecdotes, acting as the unifying principle between a motley throng of figures of all types and ages, hailing from very various social levels and playing their individual parts on a crowded stage. Yet this figurative multiplicity does not blind us to the dazzling sumptuosity of the painter's palette, the subtle alchemy of nuances, the glowing density of the local tones. Bright colors, gay colors, the colors of people in their "Sunday best" —and, combined and contrasted with vivid blues, acid or bluish greens, with snowy white, red supplies the major accents. A little patch of yellow sand, dappled with touches of pale green, is purposely left bare of figures; it forms an oasis of brilliant light in the middle of the picture and the starting point of two registers of color basic to the composition and spreading out across it, one consisting of greyish browns occupying the lower half and the other, all in tones of ochreous grey, filling the upper zone. Together, they form a vertical backcloth against which the actors play their various parts. These actors are as clearly, forthrightly delineated as the figure studies in the *Seven Virtues* engraving; but here they no longer have that air of marionettes which gave a certain gawkiness to the figures in the *Blue Cloak*; rather, they are rendered in a wholly lifelike manner, indeed there is something almost disconcerting in the stark simplicity of their gestures, attitudes and antics.

In his illuminating description of the period that Bruegel brings so vividly to life in this picture, Lucien Febvre remarks that it was a period capable of hearing, catching the smells that hovered in the air and registering sounds, but it did not *begin by seeing*. In his intensive study of 16th-century writers one thing particularly struck our erudite historian: that "with very rare exceptions they were incapable of making a lifelike sketch of a human personality so that the reader could visualize the man in question as he was in flesh and blood." This is shrewdly said; and we find similar shortcomings in most of the painting of the time —due allowance being made for its other merits and the pleasure of the eye provided by an adroit handling of color. But Bruegel was an

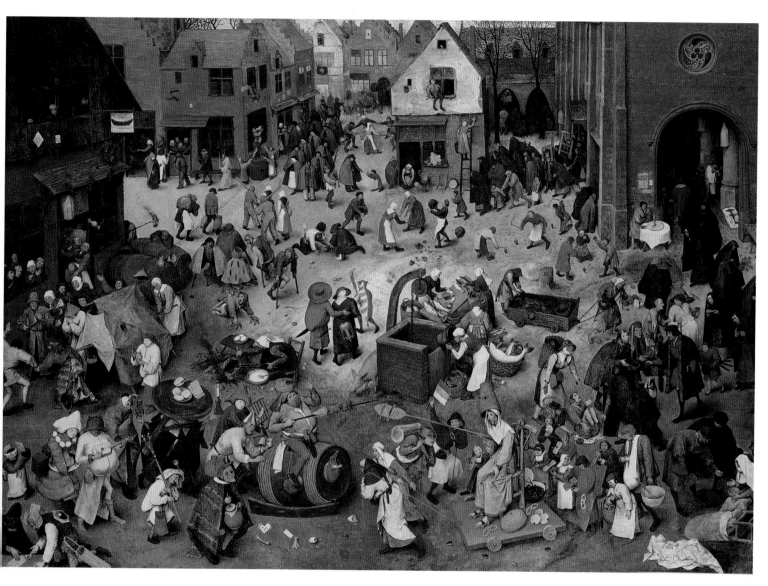

The Fight Between Carnival and Lent, 1559.

exception to the rule, a "triumphant harbinger of modern times." He brought to bear a virgin eye, untrammeled by convention, on the world around him. He shows us real men living out their lives. Not those who shape the destinies of nations, but men who toil and suffer and take their pleasures simply, anonymously, at the lowest social level; men without wealth or eminence. He does not pick and chose; all, such as they are, arouse his interest. Whether young or wasted by the years, healthy or infirm, frail or stalwart, well-built or misshapen, sad or merry, good Christians or sinners—all alike are pasture to his eyes and, for once, in *Carnival and Lent*, he brings them together in the heart of a typically Flemish village on a day of Carnival. For once only. This census-like inventory is unique of its kind, without a counterpart in the

The Fight Between Carnival and Lent, Details, 1559.

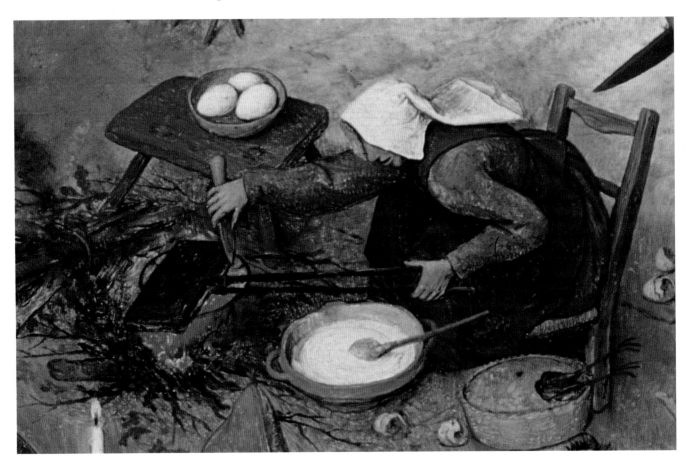

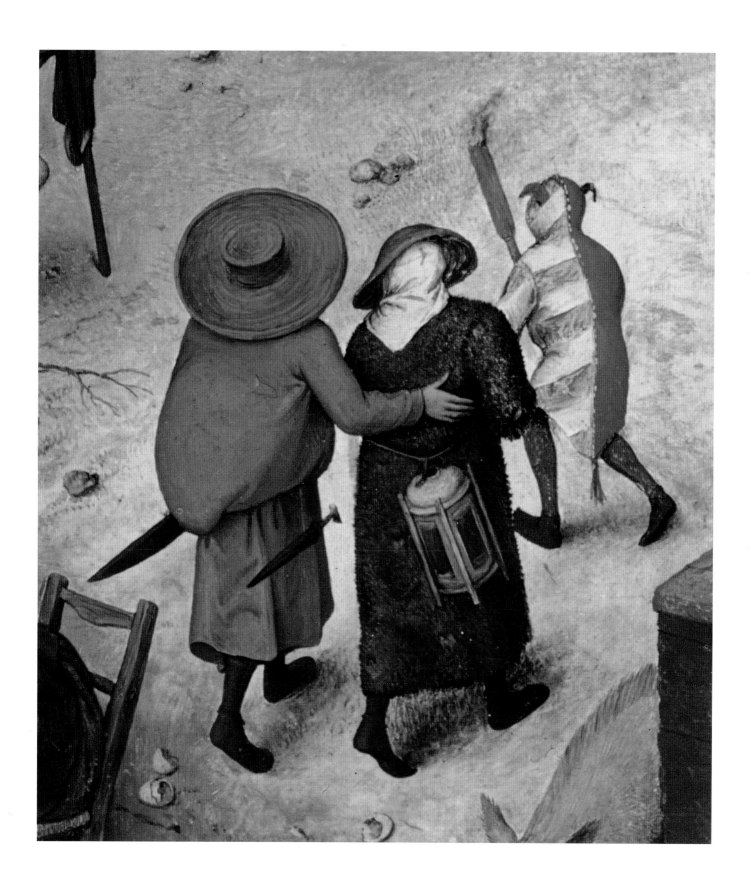

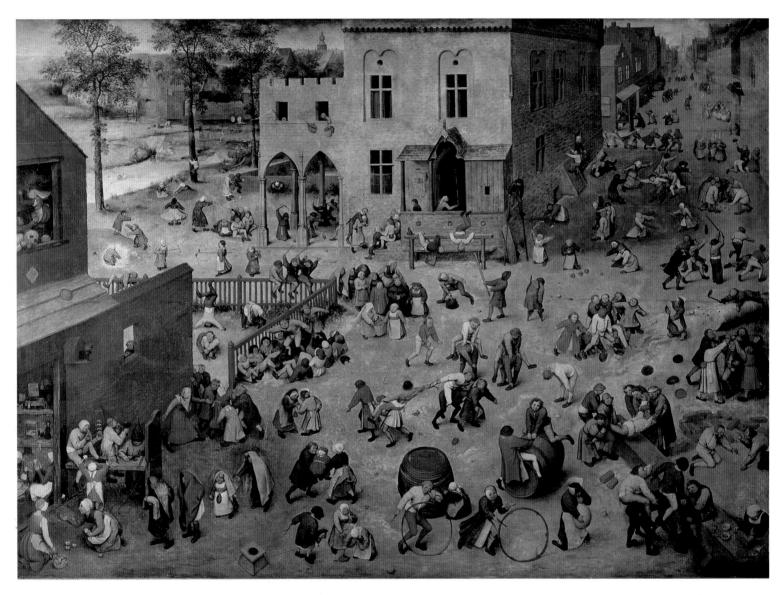

Children's Games, 1560.

whole world of painting. It contains a wealth of contrasts—golden rule of all creative art—both simultaneous and suggestive. And behind every detail we sense a will to synthesis permeating the most meticulous analysis. This pictorial *summa* of humanity figured forth without disguise has an instancy denied to literature.

In view of a thesis, a young French doctor studied this picture from a professional angle and claimed to discover in it faithful renderings of the symptoms of a great number of diseases, physical and mental. He goes so far as to assert that only a trained physician could possibly have made such accurate diagnoses. "The fact that the great Flemish master has brought to bear on his figures the eye of an expert clinician rules out any notion of their being solely the products of his imagination" —such is Dr. T. M. Torrilhon's conclusion. Though most certainly there is nothing "imaginary" in this particular work, we need not resort to any such far-fetched hypothesis in order to account for Bruegel's "realism." The truth lies elsewhere—in the rich endowment of the mind of a great creative artist who, better and more discerningly than others, could single out and body forth what was unique, peculiar to itself, in the object of his contemplation.

The leading theme came from a folk tale that had already been pictorialized by Bosch. But quite possibly there was also an allusion to the religious conflicts of the period. According to C.G. Stridbeck the man with an enormous paunch astride a barrel who impersonates King Carnival and heads a shambling rout of masked figures, represents the Lutheran movement; while Lent, a gaunt old harridan sitting on a go-cart drawn by a monk and a nun, symbolizes the Catholic Church.

However this may be in *Carnival and Lent*, there is no trace of any such symbolism in *Children's Games*, a perfectly straightforward work, indeed the only one of Bruegel's works to carry no recondite allusions or moral innuendos. All goes to show that it formed part of a cycle of the seasons, half of which is lost, and represented "High Summer," while *Carnival and Lent* stood for early Spring. Any other interpretation (*see* Tietze-Conrat, Stridbeck) must certainly be ruled out.

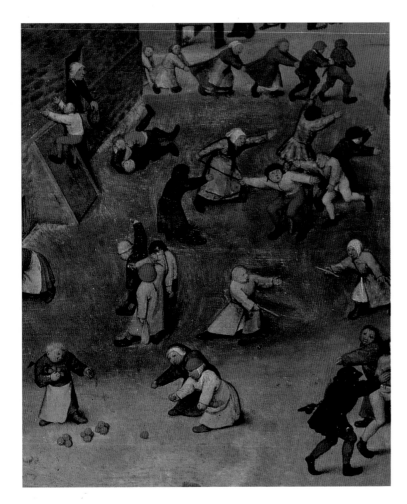 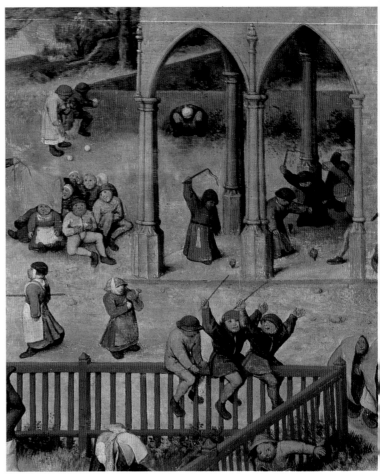

Children's Games, Details, 1560.

It is clear that Bruegel had a lively sense of visual actuality, and far less of that obsession with peasant life of which he used to be accused. In *Children's Games* he shows another facet of everyday, small-town life, studied in its inception, so to say: the childhood of the rising generation. This delightful work was wholly original; attempts to link it up with any local art tradition or to trace its sources to Metsys, Bellegambe or Gossart lead nowhere. What we have here is a unique "encyclopedia of games," indispensable to any would-be historian of the recreations of childhood through the ages.

Alone, in couples, in threesomes or in groups, over two hundred children are disporting themselves in the marketplace of a country town, near the bank of a small stream beyond which lies open country. The landscape is superbly rendered, a green expanse in which air freely circulates, shimmering with the heat of a summer afternoon. With unfailing verve Bruegel depicts in detail a host of games, many of which we recognize, with something of a shock, as those of our own childhood: blind man's buff, leapfrog, bowls, ring-o'-roses, somersaults, trundling hoops, peg-top spinning, walking on stilts, and so forth. This enumeration might easily have become monotonous, not to say tedious, if it were no more than a series of vignettes and each

Children's Games, Detail, 1560.

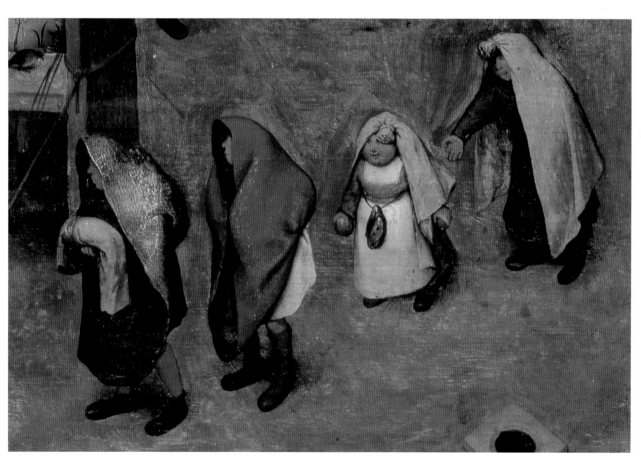

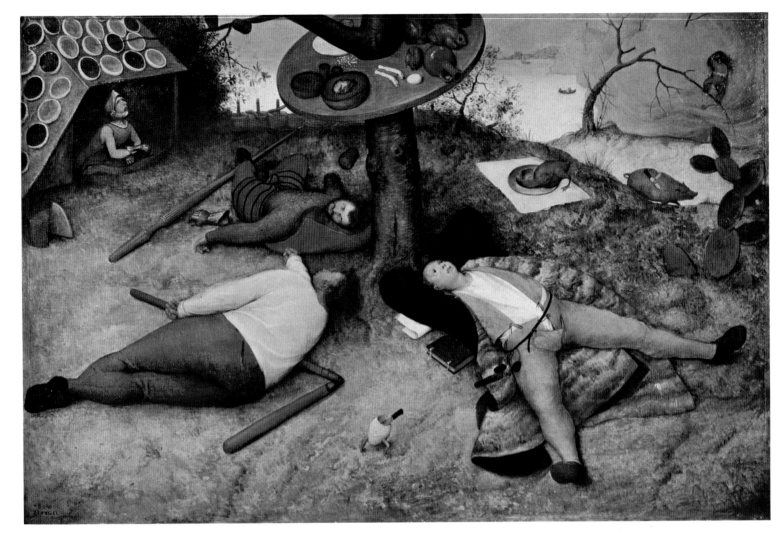

The Land of Cockaigne, 1567.

small scene were treated in isolation. But once again the artist has effortlessly avoided any such effect of fragmentation. To begin with, the colors are *constructive*. Less sumptuous and less modulated than in the previous picture, they are lighter, soberer, built up into a more effective compositional pattern. Against the yellowish tones of the sandy soil, the blues and greens dominate and carry the red bell-like patches of the children's garments. The contour lines of forms are more synthetic and circumscribe denser, stronger, more positive local tones. But the organic unity of the initial conception makes its presence felt

in every tiny figure. None is individualized, each is a "condensation" of the crowd. When the heads are turned towards us (usually they are shown in back view or in profile), all these little faces, round as billiard balls with two black holes for eyes, diminutive mouths and flattened noses, are curiously impersonal. It is their gestures that tell us what they are after and the sort of youngsters they are: awkward or nimble, bright or backward. And they foreshadow the time when movement *in itself* was to become an object of expression.

Two later pictures carry this process a stage further: the *Land of Cockaigne* (Munich), painted in 1567, and the *Birdnester*, painted in the following year (Vienna). A comparison of these two pictures is rewarding since they show how at every stage of his brief career Bruegel made a point of following his first, instinctive impulses. For they reveal in the most convincing manner the two poles between which he always oscillated, almost as if he were seeking to demonstrate to others and to himself his ability to figure forth with equal success the new world in terms of the ancient conception of space, and vice versa. Thus in the *Land of Cockaigne* he limits space to the two dimensions of the vertical plane upon which are presented in strong relief and in marked foreshortening three massive figures so placed as to seem to be projected bodily towards the spectator. In the *Birdnester*, on the contrary, we have a landscape prospect set out in deep recession and our gaze is led towards a distant, delicately indicated horizon. In the one case we have, if in a "modernized" form, the medieval conception of space basic to the *Blue Cloak, Carnival and Lent* and *Children's Games*; in the other, Bruegel resorts to the technique employed in his first panoramic landscapes. In both pictures he seems to be testing out, in terms of the visible, the modifications that contemporary thought had brought to the relations between man and the world around him. And both reveal a similar economy of means oriented towards the mastery of a style, while the imagery, still that of a "topsy-turvy world," but here attuned to a gentler mood, testifies to the feelings that lay deepest, ineradicably, in the artist's heart.

The theme of the *Land of Cockaigne* derives from a Flemish proverb: "Nothing is stupider than a lazy glutton." Three men have fled from the Spanish Terror so as to bask the hours away in a land of fabulous delights. Besides their costumes, various attributes (a lance, a flail, a book) indicate their respective callings: one is a knight, the second a peasant, the third a scholar. Plunged in a sort of stupor, they seem welded to the soil, incorporated into the amply swelling curves of Mother Earth, and their bodies are boldly reduced to the elementary geometrical forms—sphere, cone and cylinder—which, after being used by Fouquet and Giotto as bases of their plastic realizations, were to become almost an obsession with Cézanne. Their limbs are tubular, their arms cylindrical, their heads and bellies round, and their thighs conical; rarely has modeling so sober produced so powerful an effect of density and monumentality. The three figures are spaced out around the foot of a docked tree-trunk on which rests a circular table, their bodies jutting out like the spokes of a wheel—a wheel that has ceased rotating. Here it would seem that the painter has combined with the above-quoted proverb the ancient notion of the "Wheel of Fortune." We owe this ingenious hypothesis to Louis Lebeer, the erudite former conservator of the Cabinet des Estampes at Brussels, who has also published a hitherto unnoticed print by Pieter Balten (a contemporary of Bruegel), accompanied by an illuminating commentary and, better still, by a Dutch text of 1546, in which the "Luilekkerland" (Land of Cockaigne) is viewed from an angle hitherto neglected by its many commentators. "Until now this land was not known to any man save the ne'er-do-wells who first discovered it. All those who wish to go there must be men of exceeding courage and ready to undergo great hardships, for that land is cut off from the world by a very long and lofty mount of cornmeal cake through which they have to eat their way before coming to the aforesaid, most famous country, well known to scapegraces and men who have cast away every scrap of decency and virtue. For there is no greater disgrace in that country than to behave virtuously, sagely and honorably, to practice good manners and to earn

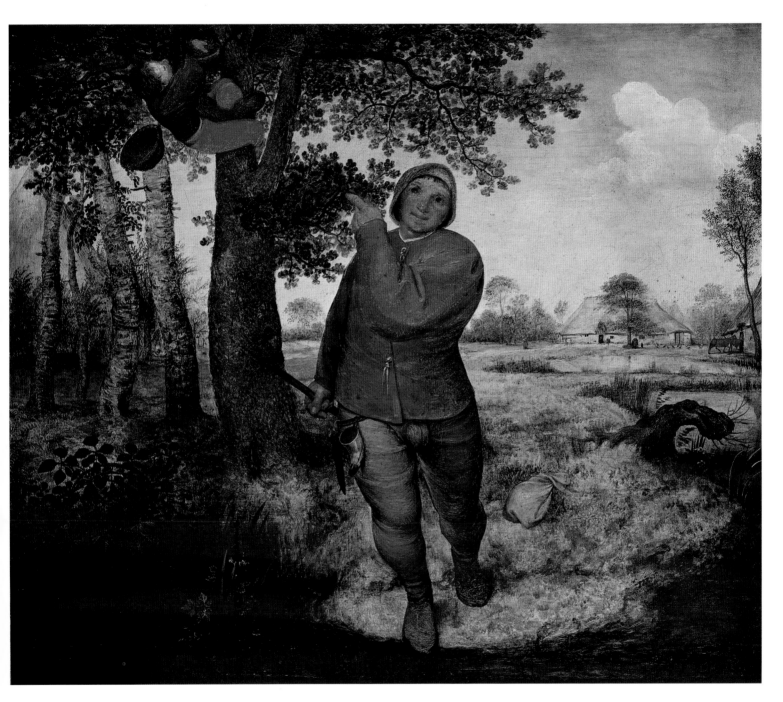

The Birdnester, 1568.

one's daily bread by the labor of one's hands. The man who leads a righteous, honest life is loathed by all, and sooner or later banished from that land. Likewise he who is wise and has a good understanding is greatly scorned and none makes him welcome."

The *Birdnester*, too, illustrates a Flemish proverb: "The man who knows where the nest is has the knowledge, but he who takes it has the nest." In this delightful picture (there is a preliminary drawing for it in the Uffizi, Florence) Bruegel anticipates both Courbet and Corot. By a judicious handling of local tones and values, he brings out to the most telling effect the contrast between the monumentalism, clear-cut form and textural density of the central figure, which supplies the vertical axis of the composition, and the fragile beauty of the far-flung, faintly misted landscape, all in nuances and values. Were it not that these terms have been garbled and overworked in modern criticism, we would be inclined to say that in this poem we have in form and color the fulfillment of the painter's twofold vocation—impressionist and expressionist.

Here (and this is exceptional in Bruegel's work), the burly peasant is presented full-face, staring straight towards us with a vacant, impersonal gaze that seems to have no thought behind it. He has the same round eyes, flattened nose and sketchily indicated mouth that we found in the stylized youngsters of *Children's Games*. Obviously Bruegel lacks the knack of rendering a smile or the psychological content of a gaze—perhaps because he systematically refused to devote to portraiture, viewed as an independent branch of art, the same attention as was given it by contemporary humanism and by its best exponents, Moro, Key, Floris and Vermeyen. So we need not be surprised that this essentially "manly" painter, who took so little stock of the fashions of the day, never painted a female nude. Torrilhon finds in this an argument in favor of his theory that Bruegel must have been a physician; as such, the nude had no appeal for him! Be that as it may, there is no question that Bruegel was far from being the peasant artist, a drab incarnation of the spirit of his race (an uncouth spirit needless to say) and of his

milieu (thick-witted to all accounts) that at the beginning of this century some writers and art historians who should have known better thought fit to see in him. When he broke the long silence of the Gothic epoch and ushered in the art of modern times with depictions of the boisterous rejoicings of the populace, and when he broke with a long tradition of religious art, it was because "he descended from the world of the eternal into the present"—because, in a word, he could *live himself into* all that caught his eye. And for this very reason his oeuvre expresses all the more dynamically the spirit of the Northern Renaissance. He was not a painter of peasants but a great humanist—if a humanist in clogs. And this is why he could be so supreme an interpreter of everyday life and succeeded in creating a style so well adapted to the merry-makings of the populace, while there still lingered elegantly on, *diminuendo*, echoes of the genteel *fêtes* of the Burgundian patriciate.

The *Wedding Banquet* and the *Peasant Dance* (Vienna, both dating to c. 1568) form a pair; they are of the same dimensions and were almost certainly painted for the same order. This is of interest as showing it was generally recognized that Bruegel's sensibility was particularly suited to the creation of bravura pieces of this type and he had proved himself a master in this field. For the sculpturesque quality of his figures, equaling the masterly plasticity of Giotto's figurative art, does not in any way detract from the expressiveness of their attitudes, always far more natural than those of his contemporaries at Antwerp, Pieter Aertsen and Joachim Beuckelaer. And the monumentality of his forms, his supple modeling, the just balance of the masses, the vigor of his color rhythms transpose what otherwise might be mere incidents of daily life to the level of a universal art, transcending the particular and ephemeral.

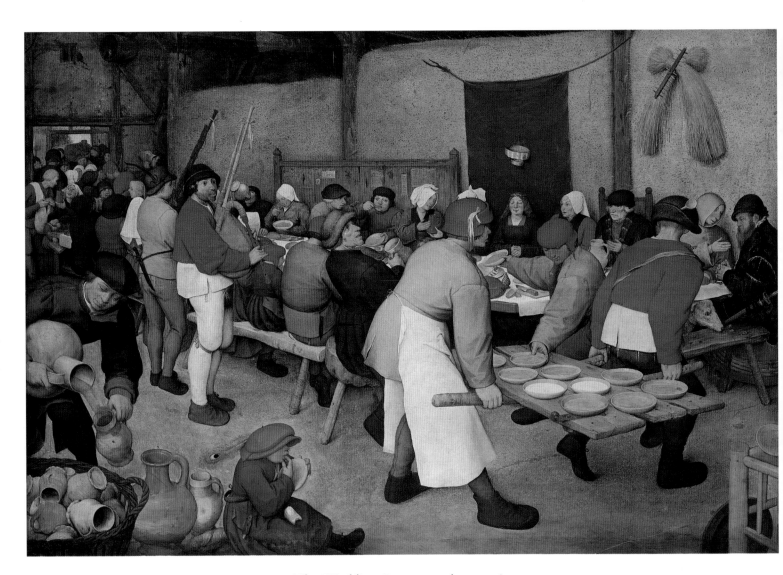

The Wedding Banquet, about 1568.

Peasant Dance, about 1558.

Seated Burgher and Cripple, about 1553-1555. Drawing.

Front and Side Views of a Standing Man, about 1558. Drawing.

A Seated and a Standing Peasant, about 1559-1563. Drawing.

Two Burghers Seen from the Back, about 1564. Drawing.

Two Seated Peasant Women Seen from the Back, about 1565. Drawing.

Seated Peasant Asleep, about 1565. Drawing.

Two Monkeys, 1562.

THE ANATOMY OF DISORDER

TESTIMONIES TO THE TIMES

I always perceive more and otherwise than I see.

JEAN-PAUL SARTRE

CLOSELY involved as he was in the everyday life of his fellow countrymen, Bruegel could not remain indifferent to the events which were soon to steep the Netherlands in blood. As early as 1533 the behavior of the Spanish troops sent by the Emperor Charles V "to take part in the war with France" had led to a nation-wide movement of revolt, and this gained strength when Philip II outraged public opinion by increasing the powers of the inquisitors in their campaign against the Calvinist heresy (1556).

Bruegel took sides; the painter of scenes of popular life became a champion of the Resistance. In the *Two Monkeys* (Berlin, signed and dated 1562) we find a hardly veiled allusion to the plight of the Flemish provinces; chained in a dark arch, the two animals have their backs turned to the enchanting panoramic view of Antwerp lightly veiled in mist. Under cover of a biblical theme that superb picture, the *Battle of the Israelites and Philistines* (Vienna, signed and dated 1562) evokes the hated presence of the foreign soldiery. The setting is grandiose, a subtly conceived and finely executed reconstitution of the artist's

The Battle of the Israelites and Philistines, 1562.

reminiscences of the South. Painted on the eve of his marriage, it raises the possibility of Bruegel's collaboration with his future mother-in-law, the miniature painter Mayken Verhulst, believed to be the author of the famous *Banquet of the Poor* (Brunswick). Signed and dated 1562, the *Fall of the Rebel Angels* (Brussels) derives its morphology from Bosch's world of fantastic beings, its aim being to denounce human folly, incarnated in the hideous hosts of Hell launching grotesquely futile attacks on the bright, invincible archangel.

Meanwhile the situation in Flanders was deteriorating, the opposition gaining in strength and growing bolder. Huguenot emissaries now

The Fall of the Rebel Angels, 1562.

were preaching in broad daylight and in *St. John the Baptist Preaching* (Budapest, signed and dated 1565) we have a discreet tribute to their courage. The country was flooded with pamphlets printed at the headquarters of the underground Calvinist movement; there were tavern brawls between Flemish patriots and Spanish soldiers; hundreds of suspects were rounded up, tortured, burnt at the stake. Once again Bruegel had recourse to Boschian "dialectic" in his *Dulle Griet* (1564, Mayer van den Bergh Museum, Antwerp), whose indictment of Spanish brutality is disguised by the archaism of the subject and its reference to a popular saying. "When you go to Hell, go sword in hand." This

St. John the Baptist Preaching, 1565.

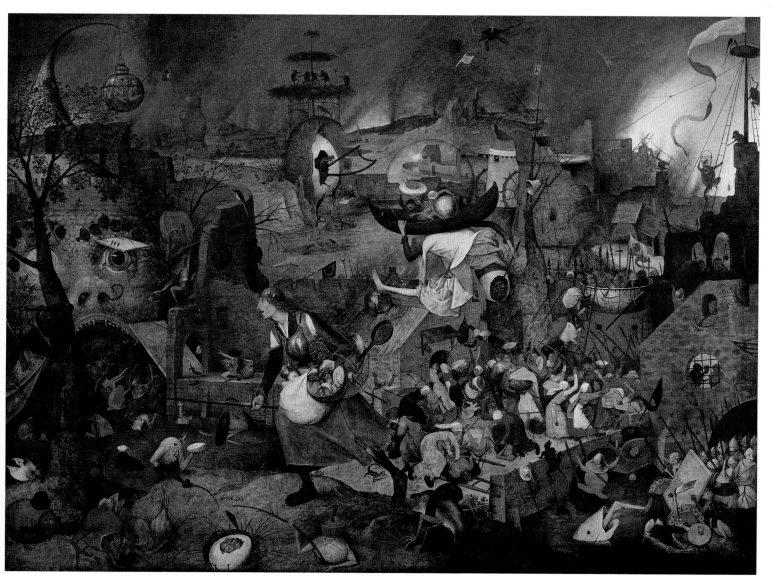

Dulle Griet, 1564.

is connected with the legend of St. Margaret vanquishing the devil, and immediately beside the gigantic form of Dulle Griet ("Mad Meg") forcing her way through the myrmidons of hell, we see the "best of Margarets known to the world, binding the devil to a mattress." The work is purposely ambivalent and lends itself to several interpretations.

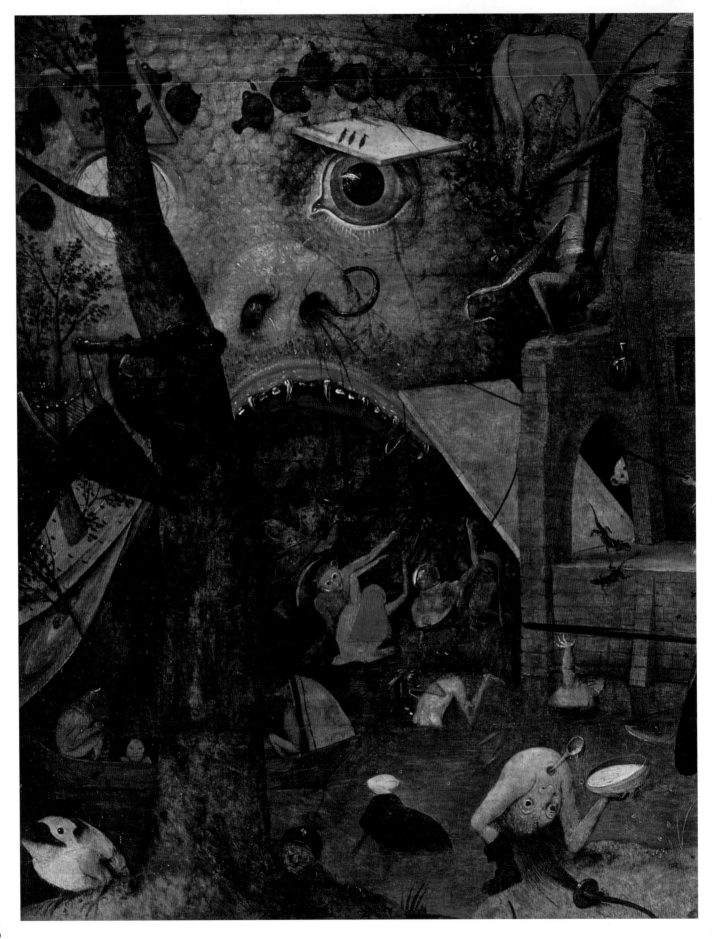

But all the allusions latent in it seem to center on a basic theme; bewildering as is the overall effect, the action advances by clean-cut successive episodes in the manner of the medieval mystery play. And what gives its paradoxical coherence to this seemingly chaotic picture, its unifying principle, is the element of fire. Through a throng of monstrous creatures, spawn of the atavistic fears that haunt the mental underworld, Dulle Griet strides boldly forward, carrying the long sword of the giants of mythology, wearing a helmet and breastplate, her eyes flashing fire, while from her gaping lips issues the song of the eternal tyrant, *wil je niet je moet wel* ("Whether you like it or not, you *shall*"). She carries baskets crammed with loot and seems completely indifferent to the havoc she has spread around her, lit up on all sides by the glare of distant conflagrations. Clearly this apocalyptic figure, central point of the composition, has a symbolic meaning; as Minnaert points out, she incarnates the spirit of oppression and brutality—elemental malevolence without a spark of pity. Two forlorn monkeys penned behind iron bars reinforce the artist's message. The horrors of the Occupation are first fruits of the "Disasters of War," and *Dulle Griet*, anticipating *Guernica*, has a like dramatic intensity. Its subterranean source is a meditation on the significance of fire. "Fire," as Bachelard has observed, "suggests the desire of change, of speeding up the march of time, of bringing all life to its conclusion—or its aftermath. Thus these musings on fire acquire an arresting and dramatic significance, since they give human destiny a wider meaning, link up the little with the great, the domestic hearth with the volcano, the life of an ember with that of the whole world. Fascinated, man responds to 'the call of the stake.' For him that fiery death is more than a change, it is a *renovation*."

In October 1565 Philip II enjoined a strict enforcement of his Edicts and, so as not to outrage public opinion, gave orders that executions

Dulle Griet, Detail: The Maw of Hell, 1564.

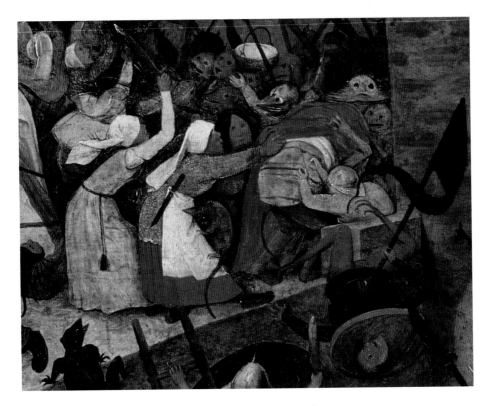

Dulle Griet, Detail: The Bridge, 1564.

were no longer to take place in public. But when 60,000 citizens were sentenced to death there was general consternation. In 1566 a small group of Calvinist noblemen founded a national league, which was promptly joined by wealthy merchants, members of the lesser nobility and the working class. The signatories of the "Compromise" of April 5, 1566, bound themselves to expel the Inquisition and to secure the abolition of the Edicts, and this nationwide resistance movement was acclaimed at a famous banquet where, dressed in beggars' clothes, the company shouted with one voice "Long live the Beggars!" and declared their resolve to enlist all classes of the nation in the struggle against tyranny. The *Beggars* (Louvre, signed and dated 1568) is an obvious allusion to this memorable occasion. It shows five pathetic cripples holding a clandestine meeting in a corner of a field swept by an April shower. Each symbolizes a different social class; the soldier has

a shako, the prince a cardboard crown, the peasant a cap, the bishop a paper miter, and all but the soldier wear a white smock to which foxtails are attached—the foxtail (an attribute of beggars) having been adopted by the signatories of the Compromise as their emblem. This solidly constructed group is depicted on the same scale as the cripples in *Carnival and Lent*, where we also find the foxtail figuring, not as an emblem of the Resistance, but as the beggar's badge. This powerful, yet delicately executed work records with unflinching objectivity the misery of the human lot at its most abject.

The Beggars, 1568.

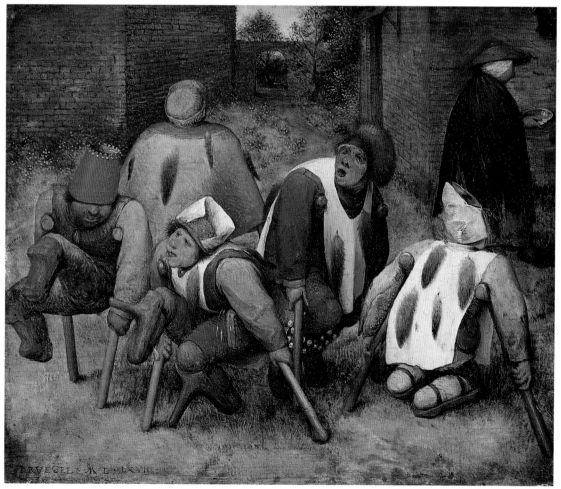

The *Procession to Calvary* (Vienna, signed and dated 1564) depicts the preliminaries of one of those public executions which strung up the nerves of the populace "beyond all that the temper and condition of the country could endure," and in this deeply moving scene of hundreds of Flemish working men rounded up by Spanish mounted troops, Nature plays her part in the human tragedy. Clad in her springtime finery at the starting point of the procession, she gradually loses all her beauty as the crowd moves on towards the bleak desolation of the fatal hilltop. Though it had Flemish and Italian precedents, this picture differs from them *toto caelo*, not only as regards its iconography but also, and above all, by the scope and sensitivity of the artist's visualization of the scene. The eye is led across a maze of colorful incidents locked within the far-flung triangle of a strictly unitary viewpoint—both an optical and a figurative unity. Here Bruegel seems to be putting into practice his accumulated knowledge of man and nature, of concepts and of figures; all his ruling interests—intellectual, social, plastic and painterly—converge, guided by the master's hand, upon this crowded scene. For the composition merits careful study. How effectively, for instance, yet how discreetly, does the local color set off the bright red of the soldiers' tunics! And how remarkable is Bruegel's handling of the soil, which here serves as a backdrop, spangled with myriads of small starry patches of green, brown and pink, no longer executed with the minute precision, the smooth enamel finish and glossy greens favored by the Primitives! Here we have the beginnings of an art of "becoming," of incessant mobility, answering to the agitation of the tiny figures fanning out in all directions and filling the entire picture with sparkling, vibrant life. Upon a stormy sky a bird is wheeling, a bird of ill omen, one of those carrion crows that haunt places of execution. But it has also a plastic function and as a focal point, high in air, suggests the vastness of space—creating the same effect of fathomless depth as does the bird flying over the frozen ponds in *Hunters in the Snow*. And this sense of the awe-inspiring immensity of space is borne out also by the rendering of the sky itself.

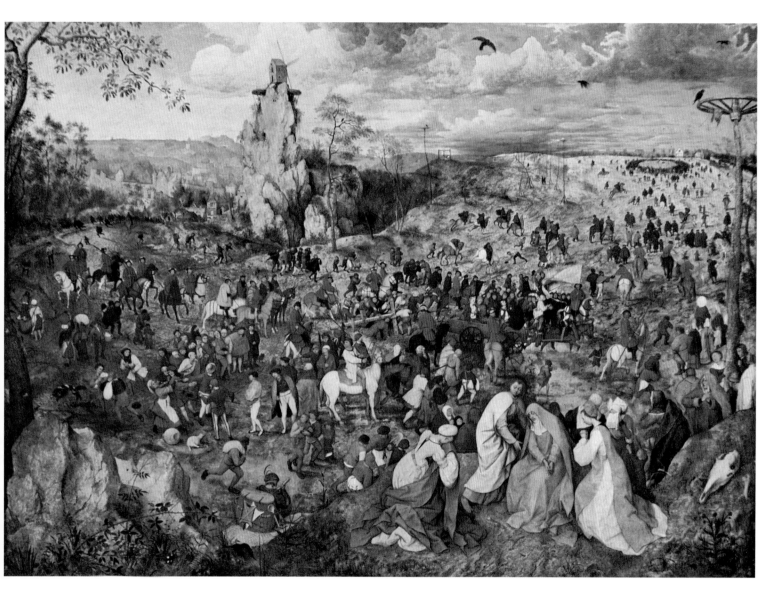

The Procession to Calvary, 1564.

The clouds are handled with a remarkable feeling for expressive values and at the same time conform to a carefully thought-out design; lowering, leaden-hued storm clouds hollow out space and thrust back to an infinite distance the white and dark blue cloud-rack billowing around them. Damisch gave us a magisterial survey of the part played by clouds as "plastic tools"—a work that no one interested in the means of pictorial construction can afford to disregard. That the author has overlooked Bruegel's remarkable contribution in this domain is regrettable but perhaps understandable. There is no question that, while in this great picture (as elsewhere) the cloud "introduces a new dimension into the composition," it also helps the painter to free

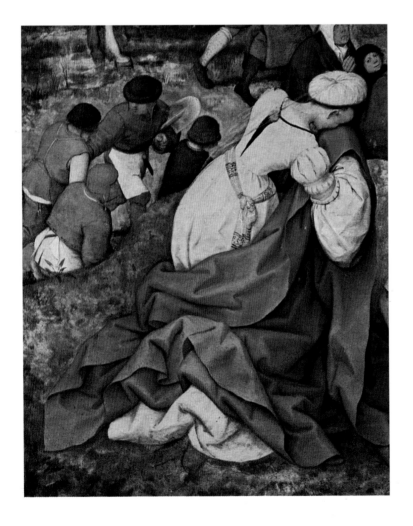

The Procession to Calvary, 1564. Details:

◁ *The Magdalen.*

▷ *The Bird of Ill Omen.*

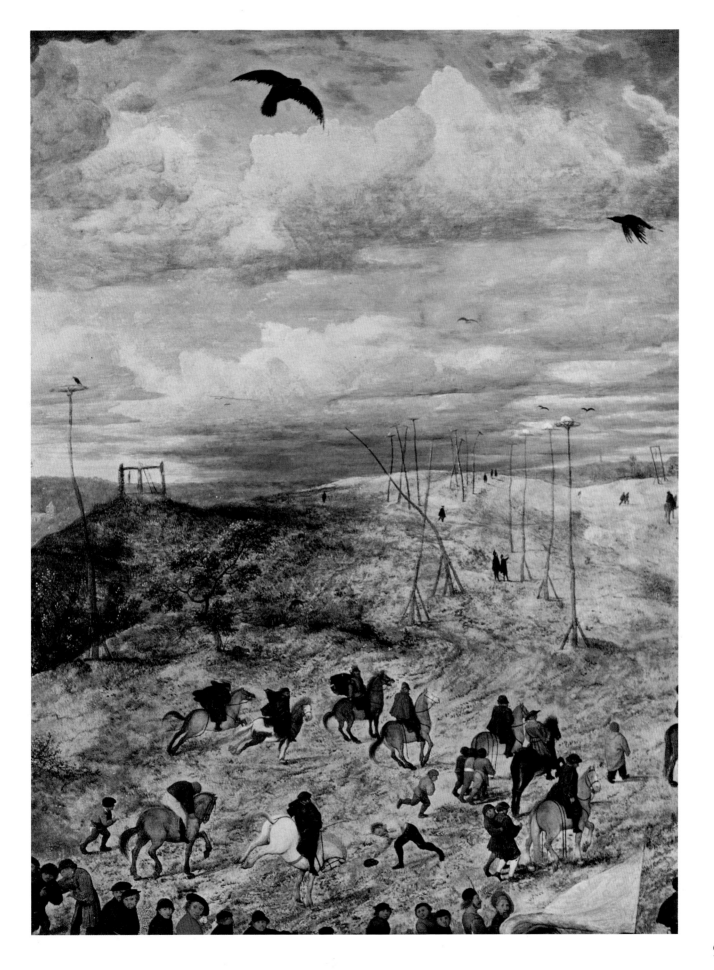

himself from any stereotyped and codified, theatrical presentation of the scene. Much more might be said about the *Procession to Calvary*, but we shall confine ourselves to drawing the reader's attention to the group of mourners in the foreground (St. John upholding the weeping Virgin, attended by the Holy Women). This group, punctuated with passages of vivid yellow, illustrates the persistence of Gothic formalism, tending towards mannerism, and in both theme and style, seems somewhat out of keeping with the intense dramatic actuality of the picture as a whole.

Meanwhile the insurrectionary movement was making alarming headway in all parts of the country, as a result both of the prevailing political anarchy and of catastrophic economic conditions; industry had come to a standstill and there was widespread unemployment. A furious outburst of iconoclasm in 1566 was accompanied by a tidal wave of destruction; bands of fanatical marauders roamed the countryside burning down churches, looting monasteries, slashing pictures, mutilating statues. Philip II took prompt action and on October 30, 1566, the Spanish regiments, stationed in Lombardy set out for the insurgent provinces. They had to cross the Alps—an arduous and exhausting performance now that winter was coming on. Bruegel employed a Gospel theme as the pretext for his grandiose evocation of an army on the march through a wild, mountainous country. The *Conversion of St. Paul* (signed and dated 1567) is his most elaborate, most fully plotted-out composition. It is given pride of place in the room in the Kunsthistorisches Museum, Vienna, which has the unique distinction of containing no less than fourteen pictures by the great Flemish master, all restored to their pristine brightness by judicious cleaning. Van Mander speaks of this work, and what struck him most were "the very beautiful rocks" that figure in it. But surely there was far more to admire: the softly dappled foliage of the fir trees, the telling counterpoint of masses, and the disposition of the long straggling line of human figures, cavalry and foot soldiers, marshaled with fine precision in a space that taxed the artist's ingenuity to the utmost. Indeed

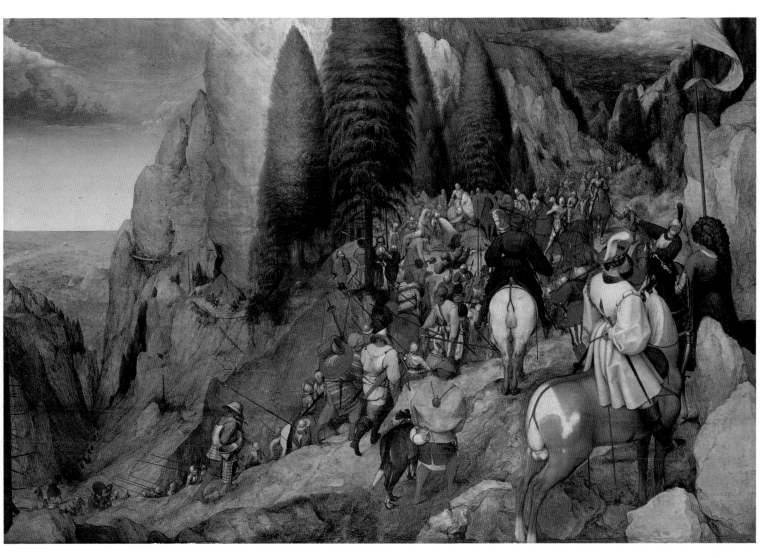

The Conversion of St. Paul, 1567.

it would seem that everything in the composition is governed by a single overriding concern: that of unifying the theme by trapping every detail in the serried meshes of a wide perspective vista. In no other work by Bruegel do we find so many indications of spatial recession: the vast plain and the city, dwarfed by distance, seen on the left between a wide rift in the cliffs; the troops streaming up from a ravine and steadily growing larger as they approach us; the criss-cross patterning of the lances; the men on horseback shown in close-up in the foreground on the right; then diminishing once again as they move away into the depths of the mountain range. And everywhere the color, subdued or brilliant, follows the changes imposed by geometrical perspective on the forms. Here, as so often in his large-scale works, Bruegel has given no prominence to the scene which is the nominal subject. This is the conversion of Saul, the Hellenized Jew, on his way from Jerusalem to Damascus, when suddenly "there shined about him a light from heaven" and, stricken with fear, he fell off his horse and heard a voice saying, "Saul, Saul, why persecutest thou me?" Like the scene of Christ staggering under the burden of the Cross in the *Procession to Calvary*, this episode occupies the exact center of the picture. Yet it is only an incident of the day's journey, and the soldiers march steadily ahead as if nothing had happened.

The *Massacre of the Innocents* (c. 1567, Vienna) shows the Duke of Alva's troops at their bloodthirsty task and it contains, Van Mander tells us, "much that actually happened, for example a peasant family begging one of the murderous soldiers to spare the life of a child he is about to kill, the mothers fainting in their grief, and other scenes done straight from life." The setting is a snowbound Brabantine village and the frozen stillness of nature contrasts with the brutal violence of the foreign soldiers, who are mounted on fiery thoroughbreds depicted with a mastery worthy of Pisanello. All the same, the essentially decorative quality of the handling raises some problems as regards this work. When we compare it with the nearby pictures we cannot fail to notice that the execution is less fluent, there is even a certain stiffness

The Massacre of the Innocents, about 1567.

in the drawing, movement is arrested in the gestures, and the style seems relatively conventional. In short, as Henri Hymans has pointed out, it lacks the finesse we expect of Bruegel. Charles de Tolnay shares the doubts expressed by Max J. Friedländer and Edouard Michel as to the authenticity of the *Massacre*. Grossmann believes it to have been painted in Bruegel's workshop and partially retouched by him, asserting that the pentimenti disclosed in X-ray photographs are proof of this. We, however, after a thorough inspection of the picture in full light, are convinced that this picture is not the work of a copyist or studio assistant. The linework may seem stiff but there is nothing hesitant about it, and only Bruegel could have supplied the brilliant color orchestration. We find saturated tones, vermilions, yellows, greens and whites, and color harmonies that assuredly derive from the palette of the master of *Children's Games* and which here serve as the staffage of a brilliantly original composition, the work of a creator in full possession of his means. That there is, perhaps, a certain lack of forcefulness is due to one of those temporary lowerings of "working pressure" which so often befall creative artists—unless it means that we have here a second version of a work that has not yet been traced. As a matter of fact, Van Puyvelde believes he has discovered it in Baron Descamps' collection in Brussels, while Grossmann makes out a case for the *Massacre* in Hampton Court. The dimensions of the Vienna picture signed BRUEG. (116 by 160 cm.) are much the same as those of the Brussels version (115 by 164.5 cm.) on which is painted the signature BRUEGEL 15..; the Hampton Court version, which seems to have been cut down on top and on the left (109.2 by 154.9 cm.), bears no signature. But—and this has its importance—the latter two pictures have more in common, iconographically, and also show much the same divergencies from the Vienna version (e.g. the placing of the horses in the left hand bottom corner, and the birds flying overhead), except for one detail which, in the Hampton Court picture, completely changes the significance of one of the most dramatic scenes. The child whom a soldier has just seized by the arm, to the despair of the father and

The Numbering at Bethlehem, 1566.

mother kneeling before the officers on horseback (as noted by Van Mander in the Vienna or the Brussels picture), has been replaced here by a young calf! Since there can be no question of an over-painting (Grossmann would certainly have detected it in his X-ray examination) this odd "correction" must have been the work of a copyist. In any case it would be an excellent idea to place the three works side by side so as to have an opportunity of studying and comparing them objectively

Towers and Gates of Amsterdam, 1562. Drawing.

without any *parti pris* or nationalistic bias—unless of course we subscribe to Blanchot's view that "all masterpieces tend to be no more than brilliant traces of the passage of an anonymous, impersonal creative power, that of Art in its entirety."

We can rest assured that it was not mere caprice that led Bruegel to take for the theme of one of his major works the *Numbering at Bethlehem* (Brussels). Here he selected from the repertory of the mystery plays a subject that lent itself to illustrating, in an indirect manner, one of the darkest hours in the history of his country. The picture is dated 1566, the year in which the iconoclasts destroyed so many public buildings and works of art. The ruins of a castle in the background —Grossmann has identified this detail with a drawing Bruegel made

in 1562 at the gates of Amsterdam—symbolize the havoc wrought by them. "All went to be taxed," we read in the Gospel of St. Luke, "everyone into his own city. And Joseph also went up from Galilee unto the city of David, which is called Bethlehem, to be taxed with Mary his espoused wife." We see Joseph and Mary arriving at Bethlehem—but this Bethlehem is a Flemish village on the banks of a frozen river. And the holy figures, given the "local color," pass unnoticed in the crowd. Children are skating, sliding, tumbling on the ice, while outside the local inn, "The Green Crown," a group of villagers are waiting in stolid resignation to hear that the war-tax has been doubled. In the whole scene, even its most trivial details, we can sense the poetic feeling characteristic of Bruegel's art. Unfortunately the colors are

The Numbering at Bethlehem, Detail: Ruins of the Castle, 1566.

dulled and countless nuances of ochre, red, violet and blue that should sing out against the whiteness of the snow come to us through a yellow haze due to repeated coats of varnish. Though the pigment itself has deteriorated in places, is it too much to hope that the authorities will soon take steps to enable us to see this picture in something of its pristine wealth of color?

Thousands of men, women and children were butchered in those tragic years whose horrors Bruegel so poignantly recorded in one of his most gripping works, masterpiece of this "topical" cycle, the *Triumph of Death* (c. 1568, Prado). Van Mander seems to be alluding to it when he talks of "a picture in which expedients of every kind are tried out against death." A mention of it (Antwerp, 1614) in the inventory of the Philippe van Valckeneer Collection confirms the fact that, though unsigned, it is certainly by Bruegel. Several authorities (Friedländer, Glück, de Tolnay, Jedlicka, Grossmann) date it to about 1562, the period of the *Fall of the Rebel Angels*. Hulin de Loo, however, would assign it to about 1566, the period of the winter landscapes (the *Numbering at Bethlehem* and *Landscape with Skaters and Bird-Trap* in the Delporte Collection, Brussels). We are inclined to agree with Edouard Michel who thinks it was painted between 1566 and 1569. Profiting by the discoveries whose outcome was the *Conversion of St. Paul* (1567), the painter here achieved a total mastery of space and composite imagery. He has systematized the earlier "encyclopedic" layout, and lets the arabesque take care of the intricate undulations of the ground. Only a very great genius could have associated in so masterly a manner the heritage of medievaldom with the spirit of the Renaissance. Charles de Tolnay has rightly pointed out that two iconographical traditions are here combined: the Italian idea of the *Triumph of Death* by an unknown master (Galleria Regionale, Palermo) and the northern conception of the *Dance of Death*. Both are employed to paraphrase a local proverb: *Theghens de doot en is gheen verweeren* (Weapons count for nought when Death assails)—an adage which, in case of need, would have furnished the artist with a convenient "alibi."

The Triumph of Death, about 1568.

Landscape With Skaters and Bird-Trap, about 1566.

In the offing the sea is grey, the sky dark with billowing smoke, while a glow of distant fires behind the mountains shows that other regions of the earth are going up in flames. On a barren hillside whose scorched slopes are rendered in a gamut of reddish-browns, a crowd of victims is being hounded down by the invincible battalions of Death. We see Death himself riding a skinny hack and with a sweeping movement of his scythe hustling the crowd into the gaping mouth of an enormous trap—a grim prefiguration of the death-ovens of the future and a reminiscence of the jaws of Hell into which we have

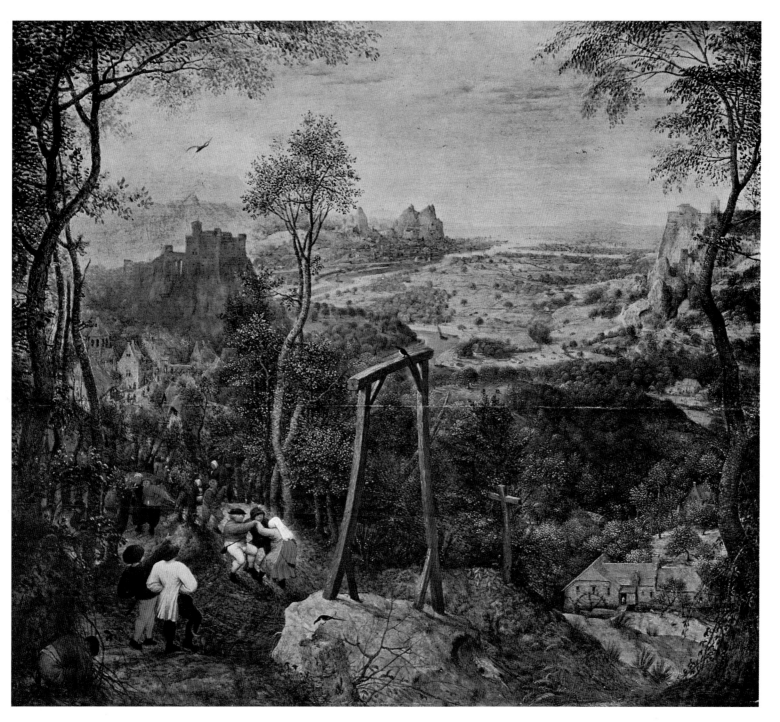

The Magpie on the Gallows, 1568.

already seen "Dulle Griet" boldly advancing. Collective massacres, tortures and hangings, cartloads of skulls, trumpet-blowing skeletons, gibbets and gallows, fires and shipwreck, flashes of apocalyptic light —all are here, integrated into a stupendous whole by the genius of a master magician of the brush. Nothing is lacking, not even a little patch of unburnt grass—an effect of contrast borrowed from Bosch—where we see two lovers, depicted with mannerist elegance, happily making music together. Here the true tragedy lies below the surface; we can sense its presence under the gorgeous counterpoint of plastic form and color. Salvador Dali and Yves Tanguy certainly owe something to the great Flemish visionary who now addressed, across the light mists veiling the *Magpie on the Gallows*, a last, deeply moving challenge to the forces of oppression. In this small picture are intimations of all the later developments of Flemish landscape art. On a knoll in the foreground, a patch of woodland, done in touches of brown, pink and green, and sparkling with broken lights, overlooks a wide stretch of open country all in pale greens, aerial blues and pearly white. A cross, marking a victim's grave, stands beside the gibbet. Nonetheless the Flemings have not lost their native cheerfulness, and we see a little group of countryfolk dancing nearby. The gay hues of their garments —vermilion, brown and blue—emphasize the contrast between life and death. In a corner a peasant is gathering sticks, heedless of the grim reminder overhead. As an old Flemish proverb had it, "flowers also grow on the pathway to the gallows."

Bruegel made many other works inspired by contemporary events, but (Van Mander tells us) "as some were too biting and sharp, he had them burnt by his wife when he lay on his deathbed, fearing they might get her into trouble."

MAN'S PLACE IN THE UNIVERSE

NATURA NATURATA

> O Earth, may thy summer, thy rains, thy autumn,
> and thy winter too, give us abundance! May thy
> dews, thy frosts, thy springs, thy passing years, thy
> seasons, day and night, be for us so many symbols
> of plenitude!
> O Earth, give me the riches of nature for which
> I long so ardently!
> O Earth, my Mother Earth, order my life!
>
> ATHARVA VEDA

IN the summer of 1563, Bruegel went to live in Brussels. Meanwhile, in far-off Italy, Veronese and Tintoretto had just painted their versions of the *Marriage at Cana*. In France the School of Fontainebleau was propagating good manners and flaunting "all the allurements of unblushing beauty." At Antwerp Frans Floris, devotee of Michelangelo, was the fashionable painter; Antonio Moro, the dignified interpreter of the faces of the eminent. Pourbus, at Bruges, was painting amiable family groups. Everywhere the forms of thought were being recast in the mold of Platonic idealism. History and mythology invaded all the major forms of art, which now became prolix and pretentious, deliberately designed to impress the public, and amenable to every sort of artifice. The manner of its saying counted for more than the thing said, however excellent. A taste for telling effects, for virtuosity, got the better of that simple, forthright language which Bruegel kept to so successfully even when conveying allusions, whether veiled or crystal-clear, to the evils of the age. Naturally enough he was the target of sarcastic comments from the Romanist

painters, and no less naturally Ortelius spontaneously sprang to his defense against the calumnies of jealousy or ignorance. "Those painters," the erudite geographer declared, "who depict good-looking persons in the flower of their age and try to add to painting an adventitious note of elegance and charm that they get from their own minds, entirely falsify the image and, in diverging from the model before them, also depart from real beauty. Our Bruegel is free of this defect." There is an antique, Roman flavor in this eulogy, and we need to put it back into its humanist context, to appreciate its phraseology and its challenging unorthodoxy. For, in so speaking, Ortelius clearly dissented from the idealist conception of beauty then in the ascendant —the conception we today describe as "classical." And it was only to be expected that with his scientific turn of mind he should be captivated by the lucidity of Bruegel's approach to the world of appearances, always by the most natural and direct path—the path that Schopenhauer, too, was to advocate, with no uncertain voice, at a later day.

For Bruegel was no less conscious than Braque of the fact that "economy of means stimulates creation, gives rise to new forms and is the source of *style*." But since he made it his task to interrogate nature indefatigably, portraying it in images bearing the authentic stamp of truth, Bruegel usually passes for a realist: an absurd misnomer that will sooner or later have to be expunged from accounts of him in text books, manuals of art history and lectures. He was as far removed from realism as from any formal intellectualism. What he did was to think out, build up and body forth—always in a spirit of humility—a sober, strictly ordered range of "plastic equivalents": equivalents of a conception of the world he had arrived at as the result of personal visual experience, registered with exceptional sensitivity, then assimilated, sublimated and integrated into an organic whole. Bruegel's art, as Dufrenne has observed, "stands for expression at its freest, breaking loose from the perceived object which it 'represents,' and thus becoming at once an affective structure and a sort of reclassification of the universe."

Since use has just been made of that treacherous term "realism," let us take this opportunity of controverting one of those commonplaces which, masquerading as truisms, have a way of cropping up from time to time, like automatic reflexes, in contemporary criticism. It is indeed dismaying to read in *Dialogue avec le visible* by René Huyghe, that "Flemish realism" answered to "the essentially earthbound tastes of a middle class obsessed, for professional reasons, with the material value of the objects it dealt in," and was based on an "exact reproduction of the substances of which these objects are made." For one thing this so-called realism needs to be related to the new world view mentioned above; and, secondly, if the *equivalents* we spoke of have special accents which in a general way characterize the art of Flanders, and differentiate it from the art of Italy, India or Japan, this is because they are due to a keen sense of tactile values and a habit of patient observation and analysis (a matter of temperament); and also because their whole conception derives from a climate (Taine was right!) that, exceptionally temperate, without extremes of heat or cold, is kindly to man, promotes a certain type of meditation and (as regards pictorial art) a sparing use of colors, bathed in a diffused, filtered light that brings out relief and never dazzles. Indeed this characteristically "nordic" environment lies at the origin of the historical, social and economic conditions prevailing in the Low Countries and of their art as well.

Closely involved though he was in this environment—we have already said how accessible he was to local influences—Bruegel nonetheless practised a sturdy independence; as when he had the audacity to paint the *Triumph of Death* at the Court, in the Emperor's personal "cabinet" (*Wunderkammer*)—such, anyhow, was the story circulated in the 17th century among the local picture dealers. (This anecdote should, however, be regarded more as a symbol of the liberties the painter notoriously indulged in than as sober fact; historically speaking, everything seems to indicate that the picture was painted in Margaret of Parma's palace.) In any case Bruegel was assuredly the prototype of the independent artist. Though light-hearted on occasion

Death of the Virgin, about 1564. Grisaille.

(there is no need to discredit Van Mander's story of his "pranks"), he was self-willed, uncompromising, and took himself and his art with a high seriousness—all this is clearly indicated in that famous drawing, *The Painter and the Connoisseur*, in which the artist certainly has given us a likeness of himself.

It is obvious that Bruegel held tenaciously to the program he had set himself. He seems to have consistently turned his back on the profits that might have been got from painting altarpieces and pictures for churches, not to mention nudes and portraits. A rare exception to the rule is that curious *Adoration of the Kings* in the National Gallery, London, the subject of remarkable exegeses by Max Dvořák and Van Beselaere, which, were it not signed and dated (1564), we might hesitate about attributing to Bruegel, so overcrowded, mannered and curiously inert is the composition. On the other hand, the small (signed) *Death of the Virgin* (Upton House, Banbury, National Trust), rendered in delicate grisaille, is a truly remarkable achievement, in a class by itself. Unique in Bruegel's oeuvre and indeed in all the art of the century, it anticipates in a most singular way Rembrandt's "incandescent chiaroscuro." It was probably painted for Ortelius in the same year as the *Adoration*. Destined to be the pearl of the Rubens collection (where it is listed: *Death of Our Lady, black and white*), it alone would have amply justified the exhibition of Flemish works in British collections which took place in Bruges in 1956.

Bruegel seems to have worked only for a relatively small circle of friends, connoisseurs and collectors. There is no reason to think that when he settled in Brussels he devoted part of his time, as some have supposed, to working for a tapestry weaver. On the contrary, he was more engrossed than ever in painting proper; so much so that he virtually gave up making designs for engraving. Meanwhile, however, he tried out a new technique, which unfortunately had no sequel; he directly traced a design with a graver on a copper plate, to which he himself then applied a mordant. In spite of some rather inexpert retouchings with the burin, this etching, *Hunting Wild Rabbits* (1566), is a little masterpiece. Judging by the works that have come down to us, Bruegel's creative activity during the last six years of his life must have been stupendous; and it showed no sign of flagging right up to his death, due (so a doctor at Brussels, an admirer of the painter, has surmised) to a stomach ulcer. In 1564 a wealthy Antwerp businessman,

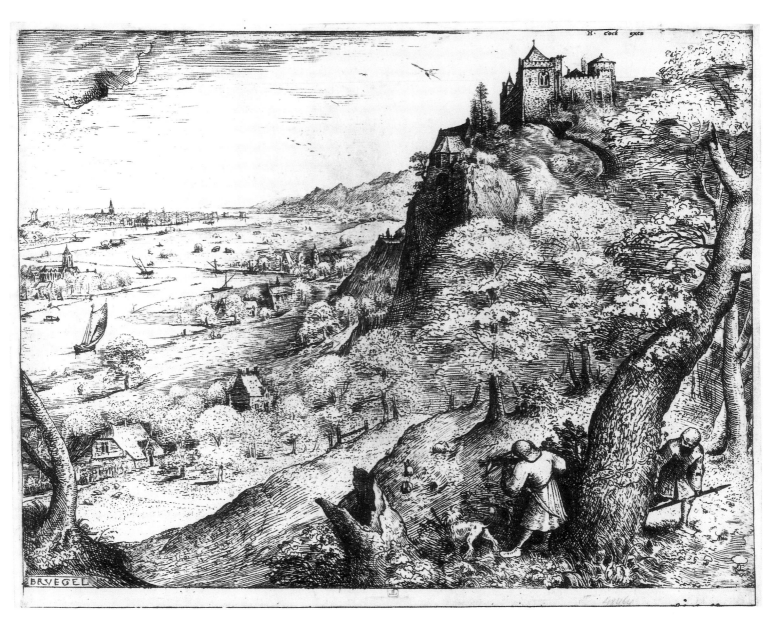

Hunting Wild Rabbits, 1566. Etching heightened with burin.

one of the discerning connoisseurs who appreciated Bruegel's lofty independence, gave him a commission that must have been after his own heart, for a large-scale picture sequence bound together by a single directive idea. Niclaes Jonghelinck asked him to make, as decorations for a salon in his new residence on the Avenue du Margrave, a series of six pictures representing *The Seasons*. This grandiose pastoral symphony struck an effective contrast with the decorations of the two other reception rooms, in one of which figured the Labors of Hercules and in the other the Liberal Arts, seventeen panels in all, painted by that brilliant Romanist Frans Floris. Jonghelinck, an eclectic connoisseur, already had several works by Bruegel, notably a *Tower of Babel* (the Vienna version) and the *Procession to Calvary*. Why Jonghelinck was obliged to make over all or part of his collection to the city of Antwerp in the following year is something of a mystery. The fact remains that on February 21, 1565, he delivered sixteen pictures by Bruegel, twenty by Floris and a Dürer to the municipal authorities (see Denucé, *Galeries d'Art*). In 1594 the city of Antwerp presented the new Governor of the Netherlands, Archduke Ernst of Austria, with the Bruegels thus acquired, to which the Archduke added the *Wedding Banquet*, bought on July 16 for 160 florins (see P. Saintenoy, *Les Arts et les Artistes à la Cour de Bruxelles*). Such was the origin of that unrivaled array of the master's painting—a third of the extant works—that can be seen today in the Kunsthistorisches Museum, Vienna.

Among these are three of the five extant pictures of the series of the *Seasons: Dark Day, Hunters in the Snow* and *Return of the Herd*. All three are signed and dated. *Haymaking* is in the National Gallery, Prague, and the *Harvesters*, signed and dated 1565, in the Metropolitan Museum, New York. All are dominated by the same philosophic conception. Man, freed at last from all legendary servitudes, is given the place he has won for himself in the natural world; the place that, on the new world view, fell to him by right. Only yesterday he was engulfed in Nature, a mere atom in the scheme of things. Yet even now, though he can assert his personality, he still feels the compulsion

to act and to exist according to the laws imposed by Nature. His life rhythm is inseparable from them and he is conditioned in all he does by his natural environment. He lives by it, depends on it—and dies of it. He cannot be isolated from the cosmos as a whole.

Sometimes Bruegel shows him toiling up a mountainside, but it is not the Cross that he is bearing, nor Calvary he is ascending. He constructs, often as not for himself, but he also labors for others; and, throughout, he remains an anonymous type-figure, a symbol pure and simple of human endeavor—an incarnation of humanity striving towards some goal that may be inaccessible but one which man forever,

Spring, 1565. Drawing.

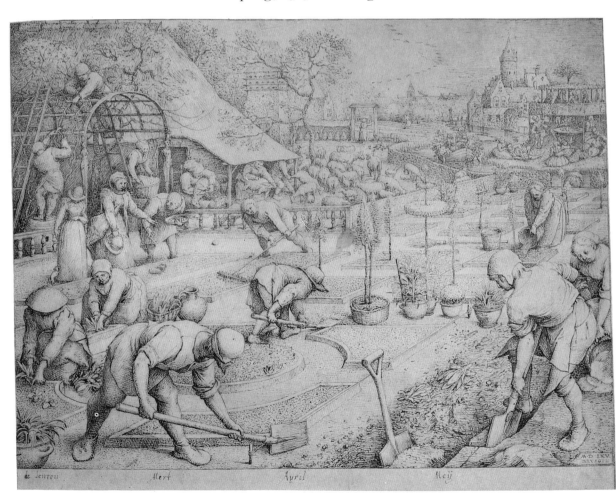

indefatigably, seeks despite the obstacles set up by natural forces. Whether he has to cross calm or raging waters, dry or rain-soaked earth, becalmed or wind-swept meadows, his movements are attuned to the natural scene. It is our appointed home: *natura naturata*. Here Bruegel's color, composition and handling of the medium make clear all he has to say without any recourse to proverbs or to folklore: only the *Dark Day* has a trace of illustration. The progress made from *Haymaking* to the *Return of the Herd* is plain to see and leads up to the spare, synthetic grandeur of *Hunters in the Snow*, that climatic work in which the painter fully found himself.

Summer, 1568. Drawing.

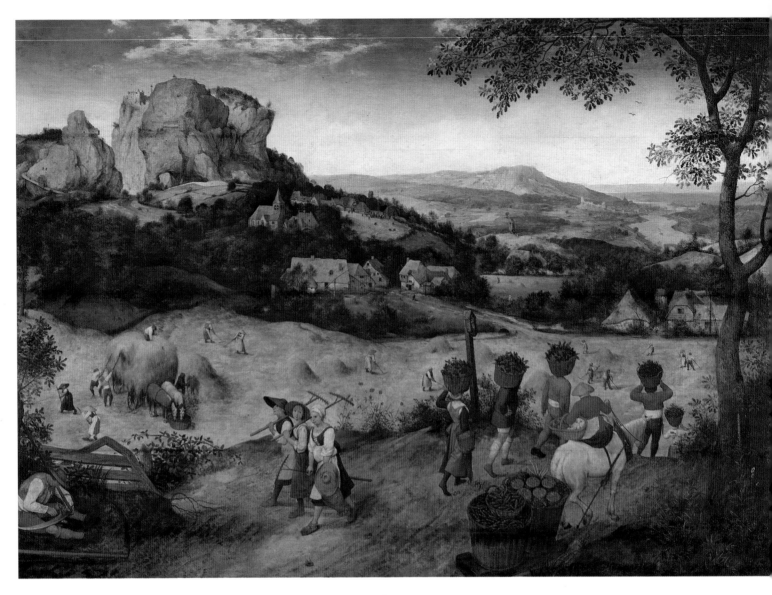

Haymaking, 1565.

In the 16th century the year began on the first of March. It seems clear that, at the instance of a wealthy citizen of Antwerp, Bruegel undertook to execute a cycle of the months and seasons, arranged in chronological order. The first picture (all trace of which is lost) must have related to the spring and depicted the rural labors appropriate to March and April; we can probably get an idea of its content from a drawing, signed and dated 1565, in the Albertina, Vienna. *Haymaking*, second phase of the yearly round, combines in our opinion the activities of the two months May and June. (Hulin de Loo and Edouard Michel, however, assign it to the month of June alone; de Tolnay to June-July; Grossmann and Genaille to July.)

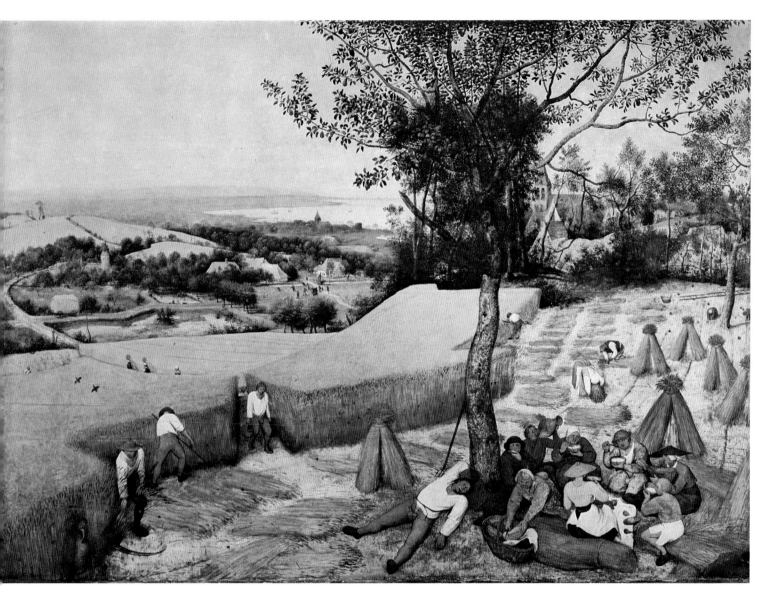

The Harvesters, 1565

The whole of this picture represents high summer, July and August—not July alone, as Edouard Michel opined. De Tolnay thinks it is meant for August-September; Grossmann and Genaille opt for the month of August only; Glück, after assigning it to July only, finally believed it to stand for July-August combined. In Flanders harvesting takes place sometimes in July, but often as not in August. In the middle distance of *Haymaking* we see a group of villagers engaged in archery: in the *Harvesters* some men are playing bowls behind the wheatfield. In both, Bruegel has associated recreations with the scene of toil. The peasant sleeping at the foot of a tree, in the foreground, prefigures a motif in the *Land of Cockaigne* (1567).

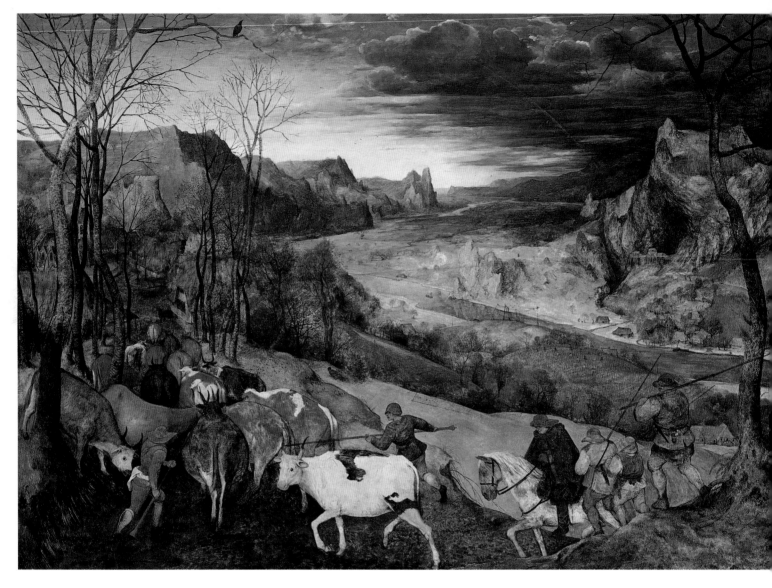

The Return of the Herd, 1565.

A slight chill in the air, the remnants of leafage on the trees in the valley, the bareness of the trees on the hilltop, swept by an icy wind, over which the herd is being driven—all go to indicate in this thoroughly original and novel work the months of September and October, the atmosphere of autumn. However, Glück is the only authority to take this view; Edouard Michel assigns the scene to November, Auner to October, de Tolnay to October-November, Grossmann to November. A diagonal, given the opposite direction to that in the preceding pictures, divides the composition into two contrasted zones. The space factor here is more strongly emphasized and the tendency to abstraction more pronounced in forms and colors.

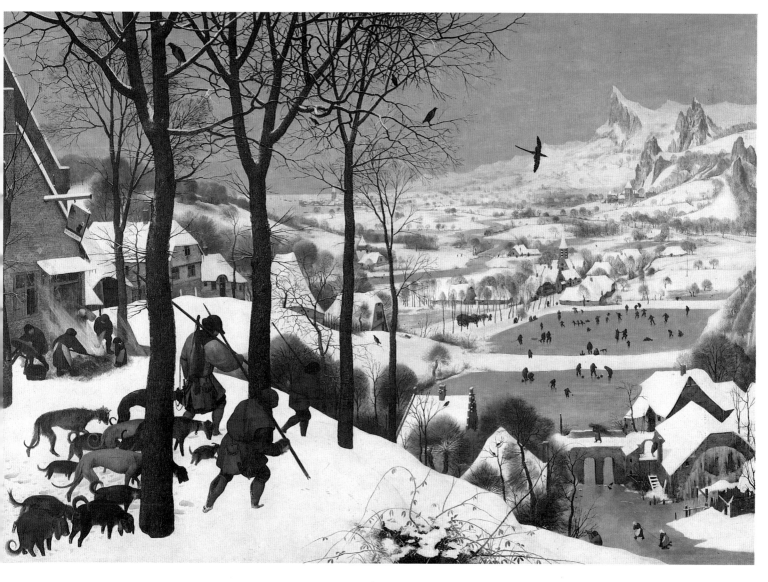

Hunters in the Snow, 1565.

This scene, culminating point of the cycle, illustrates simultaneously the months of November and December (the *Dark Day* stands for January-February). Hulin de Loo relates the *Hunters* to February, Glück to January-February, de Tolnay to December-January, Grossmann and Auner opt for January alone. The layout of this work cannot fail to bring to mind the art of the East. Particularly susceptible to the climate of opinion of his age, Bruegel reveals here, more emphatically than in his other works, man's entire subjection to natural conditions. Here we have landscape art at its purest; every trace of a symbolical background has been eliminated. The painter confronts a world he perceives and interprets as a living organism.

Brown, grey and green are the only colors permissible in the snow-bound silence of a Flemish winter's day, a silence that lies like a pall on everything, muffles even the sounds of children at play, accompanies the slow steps of the hunters and even seems to weigh on the lean backs of the hungry dogs. "Never," writes Edouard Michel, "has an artist rendered with such intensity the elegiac quality and the profound melancholy of the northern landscape in the grip of winter, and Bruegel does it without a trace of sentimentality or any superfluous elaboration. Such fine spareness is rare in northern painting." Yet much invention lies behind the air of utter naturalness; for, as in so many of Bruegel's landscapes, the scenery is manifestly composite. Here the Flanders plain, Brabantine valleys and mountains of the south, Alpine or Sicilian, are transmuted, fused into a coherent, self-consistent whole. True, the distant origins of this "cosmic" vision may perhaps be traced to the Venetian landscape as we see it in the works of Titian and Campagnola. Yet here this universal form is given the aspect of a wholly personal creation. To appreciate its high originality, we need only glance at the rural scenes the Bassanos were popularizing at the same time in Venice, which, too, depict the *Months* or *Seasons*. And in the same way as Bruegel may have drawn inspiration from the *Grimani Breviary* or the *Hennessy Book of Hours*, they drew on the tradition of the medieval Calendars. But the Italian works, no longer manifestations of a courtly art, were adapted to the taste of the upper middle class, and merely clothed the "new realism" in a traditional garb. Baldass has rightly pointed out that these scenes were meant to please the Venetian gentry, who liked being reminded of their country outings. Whereas Bruegel refused to be hampered by any such obligations and, starting out from the old notion of the divisions of time, as set forth in illuminated Calendars, he composed an epic—or rather a bucolic—in six pictures (the sixth is lost).

Properly speaking, however, the successive periods of time represented in the *Seasons*, distinguished by their appropriate labors, do not tally with the "Calendar" formula and, in this respect as well as

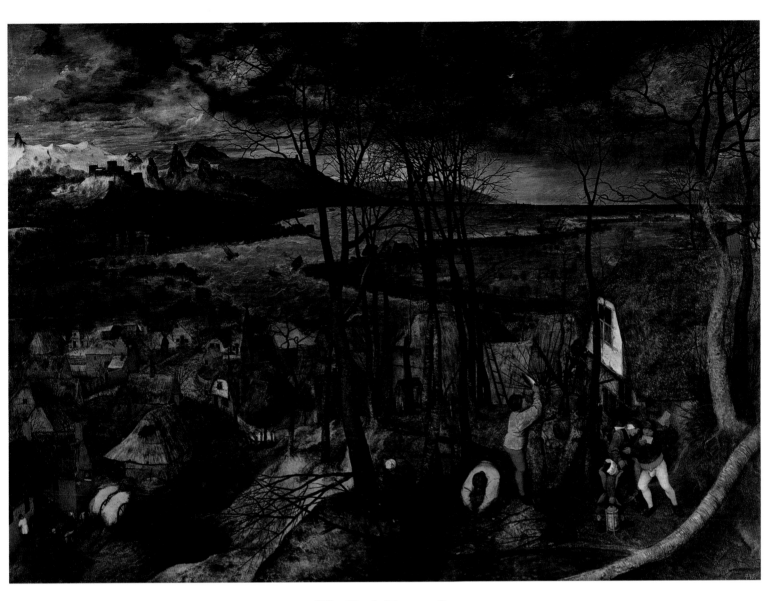

The Dark Day, 1565.

others, depart from all traditional procedures—another proof of their complete originality. Bruegel has handled them in the synthetic spirit that governs all his work. For these scenes correspond no more to the four seasonal divisions of the year than to the twelve months to which certain authorities would relate them, drawing the conclusion that the series must originally have consisted of twelve pictures. Grossmann takes his stand on the inventory of the Jonghelinck collection made in

February 1566, in which mention is made of "the Twelve Months" without further specification. He assumes that, had there been only six pictures, their names would have been recorded. He also thinks that the sequence must have formed a continuous frieze, linked together by the arabesque of the backgrounds. But we have only to confront *Hunters in the Snow* (assigned to January) with the *Dark Day* (said to illustrate February) to see that no such link exists. Furthermore, Grossmann holds that a painter in full mastery of his craft should have been capable of carrying out this task, great though it was, within a year. Here, again, we venture to differ; it seems impossible that Bruegel could have planned and executed twelve large panels in less than a year, for we must bear in mind the fact that he is known to have painted other works in that same year (1565). It is far more probable that Bruegel began work on the series in 1564 and completed and signed it early in 1565. We are also inclined to think that the synthetic mode of presentation adopted by the artist was called for by the dimensions of the room in which the picture sequence was to figure; the reception room of a private house, not the hall of a palace. Finally, a point noted many years ago by Hulin de Loo seems to have been lost sight of. Amongst other significant details in the *Dark Day* we see a child carrying a lantern and wearing round his cap a paper band decorated with floral ornaments—this is obviously the crown of the so-called "bean king," the member of a Twelfth Night party who has had the luck of getting the slice of cake in which the traditional bean is buried. Hulin de Loo also points out that we see a peasant eating one of the traditional Twelfth Night waffles. Thus there can be no question that this little scene represents January. But other details of the picture (e.g. the man pruning willows) no less clearly relate to the seasonal occupations of February and prove that this panel certainly covers *two* months. Thus there are grounds for revising the generally accepted "chronology" of the four other pictures and assuming that, throughout the series, the months were illustrated in pairs.

IMPRACTICABLE WISDOM

VANITAS VANITATUM

Ouvrons ensemble le dernier bourgeon de l'avenir.

PAUL ÉLUARD

I T IS perhaps a pity that we cannot be satisfied to feast our eyes on the strange enchantments of Bruegel's color as it is and as it speaks to us, without comment or discussion. Yet since it is charged with signs that arise from the depths, and invite us to "read" them, let us try to trace the sources of the collective dream it figures forth, a dream that one might well have thought had reached its finale in the *Months* and *Seasons*, such is the all-pervasive calm and relaxation of that glorious picture sequence. Here chance in kindly mood had brought the artist back to his first, congenital vocation, that of synthesizing the master rhythms of Nature as a whole—Nature apprehended as a living entity, home of men, plants and animals, seemingly autonomous yet dominated by an unseen power, the power of Number, which measures out her seasonal recurrences. Such was Bruegel's grandiose conception, based on a tacit pantheism.

Man, as Bruegel perceives him in the heart of Nature, is obsessed with the basic need of earning his daily bread. He hunts, reaps, tills the soil, but he also drinks and dances in his rare intervals of leisure. Freed

though he is from the servitudes of feudalism, he has no personal pretensions and also no idea that the painter who is sketching him and who often shares in his recreations can speak Greek and Latin. His senses are coarse and, in a general way, his nose is more alert than his eye. Needless to say, he speaks the language of the country and wears the usual "national costume" when at work. Poor but essentially good-natured, he is often uncouth in appearance. When the fancy takes him, he utters home-truths, often couched in the crudest terms—in fact he prides himself on his complete frankness, even if this means that his conversation is larded with expressions which, coming from his "betters," would pass for highly vulgar. He has a sense of humor, too, and displays a truculence and tartness of speech only to be found in the exuberant pages of our immortal Rabelais. But he is always thinking, like Sir Thomas More, of an ideal world of peace and social justice and, though he hardly knows the meaning of those words, he knows quite well what he wants. An impracticable wisdom, given the temper of the age. The world he lived in was "topsy-turvy," a playground of fools and knaves, and in the lowest strata of society leprosy and the plague took a constant toll of humble lives. What with incessant warfare and bad administration, economic conditions were deplorable. And the Resistance movement was passing from words to deeds, leading to savage reprisals. The authorities imprisoned, persecuted, killed without discrimination. All these infamies wrung the painter's heart, gave pause to his irony, cut short his smiles. Also, the insidious malady which now was undermining his robust health took all the gaiety out of his humor and a change came over his character. He was gripped by apprehensions, and "in his most lucid moments, the apprehension of apprehension." Once again, he felt the need to veil his secret thoughts in metaphor.

The *Storm at Sea* (Vienna) is obviously a reflection of this mental unrest. Dramatic, seething with tumultuous power, it symbolizes a state of crisis, turmoil, conflict, and transposes the human tragedy onto an elemental plane, that of cosmic forces unleashed, uncontrolled and

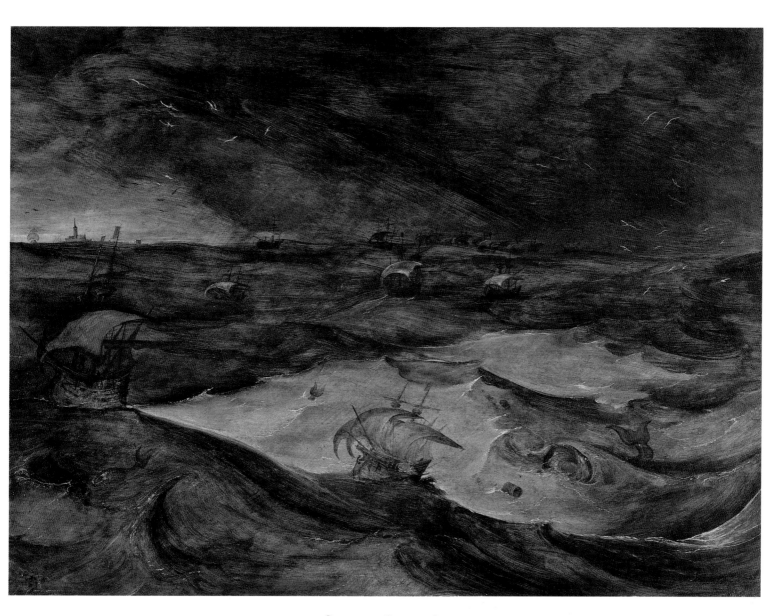

Storm at Sea, 1568.

uncontrollable. It is remarkable how time and again the painter's brush has swerved impulsively away from the firmly planned design, traces of which can still be seen. The somber, greenish colors give intense expression to the fury of the storm and the massive movement of the waves imposes on the scene a palpitating, syncopated rhythm. With its total unconstraint this amazing work might pass for a lyrical counterblast to Bruegel's many patiently constructed compositions; it has the air of an improvisation that was itself cut short, so undisciplined and unfinished does it seem in places. Might one not say, in view of the style, the brushwork and the sentiment behind this work, that in it "the future is already on the threshold"? In any case we indisputably have here an early intimation of Rubensian bravura, of the romantic sensibility, the shorthand methods of Expressionism and, what is more, a foretaste of the expressive power of the *patch* of color. (As a matter of fact the *Return of the Herd* had already shown the artist's interest in this hitherto untried technique; in the rendering of the cows viewed in foreshortening we find brushwork no less free, with the "patch" standing on the neutral underpainting left visible in places.) *Hope*, an engraving in the "Seven Virtues" series, forms a connecting link between this panel, painted we believe in 1568, and the early *Harbor of Naples*.

The comparison is rewarding, since it enables us to gauge the stock of rich experience Bruegel had amassed in the intervening years. For what grips us in the *Storm* is not the actual scene, simple to the point of obviousness, but the imprint it reveals of a great creator's personality. A high sea is running, ships are laboring in the trough of murky waves, lit with vagrant gleams, while in the foreground a whale is opening its pink jaws towards a barrel floating on the water. On the far horizon we see a church steeple outlined against a rift in the clouds. Ludwig Burchard has interpreted the symbolism of this scene; the whale, playing with a barrel thrown overboard by sailors so as to diver its attention and enable their ship to escape, represents the man who for the sake of trifles lets slip his chance of salvation. Schrade adds to

this interpretation and sees in the church standing out on the horizon a symbol of divine protection from the perils of the sea. Auner goes further; he reads into the scene an allusion to the political and religious turmoil of the age. Yet, is not the dramatic quality of rhythm and colors sufficient in itself—why search for recondite symbolism in a picture so richly satisfying as it stands? A plethora of exegeses tends to give such works meanings that may well have never crossed their author's mind.

In this, the last phase of his brief career, Bruegel had recourse to a parable in the Gospel of St. Matthew as a vehicle for summing up and expressing his melancholy ruminations on the present plight of his country and his forebodings of still worse to come. The *Parable of the*

The Blind Men, 1562. Drawing.

The Parable of the Blind, 1568.

Blind (Naples, signed and dated 1568) is based on the passage in the Gospel: "Let them alone: they be blind leaders of the blind, and if the blind lead the blind, both shall fall into the ditch." The picture enlarges on the scriptural text, which refers to only *two* blind men, and had given rise to a proverbial saying already illustrated by the painter in the background of the *Blue Cloak*. Here the smiling skepticism of the "world upside-down" has given place to the tragic sense of life. Six wretched creatures, presented in close-up, epitomize the mass of men and the collective anguish of the age. They have much the same look of abject misery as the group of cripples in *The Beggars*, which Bruegel had just painted with a monumentalism no less novel, no less compelling.

Five blind men have been foolish enough to take for their guide a man as sorely handicapped as themselves. He has led them down an incline at the end of which is a deep, muddy ditch and he himself is the first victim of his rashness. We see him fallen on his back—this gives Bruegel an opportunity for a magnificent foreshortening—and dragging down with him his five over-trustful companions, forced to share in his ignominious fate. This was bound to happen, since the men strung out in single file are linked together by their arms or the long staffs they carry. All are aligned on a diagonal that, like a strident cry, traverses and unifies the composition. As far back as 1889 Drs. Charcot and Richer in their study of the representation of disease in art (*Les Difformes et les malades dans l'art*) drew attention to Bruegel's accuracy of observation in showing all the blind men with their eyes turned upwards instead of forwards, the reason being that, lacking sight, they tend to rely on other senses, smell and hearing. What is more, each face has been studied with minute precision, and each illustrates a specific form of blindness. Thus in the eye of the central figure, with the white patch on the cornea, we have a typical case of leucoma, and the man behind him (as specialists have pointed out) is suffering from atrophy of the eyeballs. Indeed these portrayals are as ruthlessly objective as a clinical diagnosis (who was it said that a painter needs as much sang-froid as a general?). This is all the more remarkable since it was still the custom to attribute eye diseases to "vapors and tainted effluvia rising from the stomach to the brain" (T.M. Torrilhon, *op. cit.*). The nervous intensity we find in Bruegel's rendering of the tragic group may have had a physical origin; he, too, was suffering from stomach trouble at the time—in which case it would be the expression of a latent apprehension, an upsurge from the lower levels of consciousness provoked by the subject proper of the picture. The combined upward movement of eyes and head, balanced by a corresponding movement of the body of each figure, creates an overall dramatic tension, accentuated still more by the austere, low-toned, strangely hallucinating color scheme: cold greys, olive greens, brownish reds and plangent blacks.

Here we have tragic expression at its most harrowing, stepped up to an almost unbearable intensity. Nevertheless the setting is a stretch of country near a Brabantine village (identified as Pede Sainte Anne, near Brussels), bathed in the gentle light of spring and not a breath of wind ruffles its shining peace. Aerial, translucent, all in delicate strokes of the brush, it has a subtlety we do not find again till Corot.

Another striking feature of the *Parable* is the way the "chain" of blind men is caught up in the successive, ever-accelerating phases of one and the same movement, culminating in their leader's fall. Here for the first time movement is visualized both in space and in time. This was a happy stroke of inspiration, as was the crescendo of acceleration; a notion that was to be formulated only in the 17th century. But it was not until Marey's invention of the celluloid roll film in 1880, followed so brilliantly by Gilbreth in the present century, that forms of movement were dissected, their trajectories analyzed and reproduced—and this before Marcel Duchamp's "stroboscopic" masterpiece, *Nude Descending a Staircase*. These facts should help us to gauge the distance covered between the *posed* attitudes of Van der Goes' shepherds (deriving from the theater) and those of Bruegel's blind men, anticipating an optical effect with which the cinema has familiarized us. A remark by the great Dutch producer Joris Ivens conveys, better than any exegesis, how the *Parable* affects the modern sensibility: "If Bruegel were alive today he would be a film director."

After the plastic tension of this noble work, by general consent one of the summits of European art, comes a restful composition, in a discreet, "impressionist" technique. This, the *Misanthrope* (Naples), is signed and dated 1568. Like the *Parable*, it has suffered from having been done in tempera, and the medium is so unsubstantial that one would think it had been thinned with turpentine. This, the painter's last work (as it is tempting to believe, all the more so since it seems unfinished) has the pathos of a gesture of renunciation.

After seeking so long to affirm the collective vocation of the individual at issue with a world of sheer absurdity, he now shows us

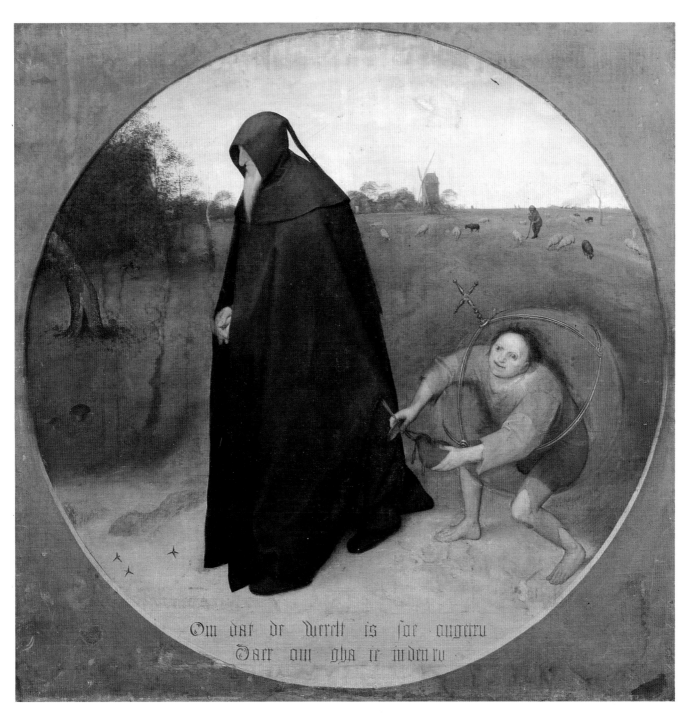

Om dat de Werelt is soe ongetru
Daer om gha ic inden ru

The Misanthrope, 1568.

the figure of the Misanthrope in mourning for a lost ideal. Wearing a long grey-blue cloak, his head enveloped in a cowl-like hood, this strange old man is nursing his grievance against the world as he enjoys —if enjoyment it can be called—the congenial solitude of a countryside to all appearances deserted.

Om dat de werelt i soe ongetru
Daer om gha ic in den ru.

Because the world is so faithless,
I go my way in mourning.

But while he goes his way an oafish dwarf has crept up behind him and is stealing his purse. The world is even more "faithless" than our sage had thought!

Thus in the grey light of a dying day, the man who had depicted with unfailing verve and mastery the joys and tragedies of Flanders in that troubled age of her history, passes discreetly from our view, cut off in his prime, disillusioned by the sad futility of man's lot on earth.

Henceforth, the centuries are his indisputable birthright; he can stretch out one hand to Giotto, the other to Fouquet, and together they will brave fair winds and foul, the changes and caprices of the future.

LIST OF ILLUSTRATIONS